PAINT LIKE
DEGAS

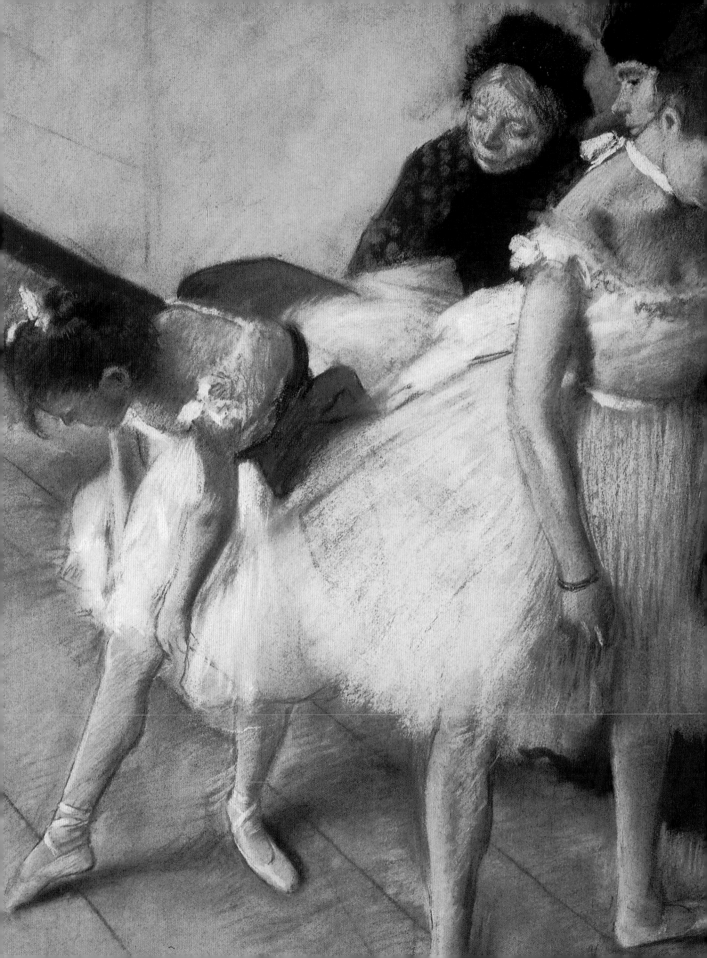

PAINT LIKE
DEGAS

UNLOCK THE SECRETS OF
THE MASTER OF MOVEMENT AND COLOR

DAMIAN CALLAN

NORTH LIGHT BOOKS

CINCINNATI, OHIO
WWW.ARTISTSNETWORK.COM

18 17 16 15 14 5 4 3 2 1

ISBN: 978-1-4403-3657-7

This book was conceived, designed, and produced by
The Ilex Press, 210 High Street, Lewes, BN7 2NS, UK

For ILEX:
PUBLISHER: Alastair Campbell
EXECUTIVE PUBLISHER: Roly Allen
MANAGING EDITOR: Nick Jones
SENIOR EDITOR: Natalia Price-Cabrera
SPECIALIST EDITOR: Frank Gallaugher
ASSISTANT EDITOR: Rachel Silverlight
COMMISSIONING EDITOR: Zara Larcombe
ART DIRECTOR: Julie Weir
DESIGNER: Lisa McCormick

Color Origination by Ivy Press Reprographics

Back cover flap: Edgar Degas,
Café-Concert at les Ambassadeurs, 1876
Front cover flap: Edgar Degas, *Four Dancers*, c. 1899

NORTH LIGHT BOOKS

CONTENTS

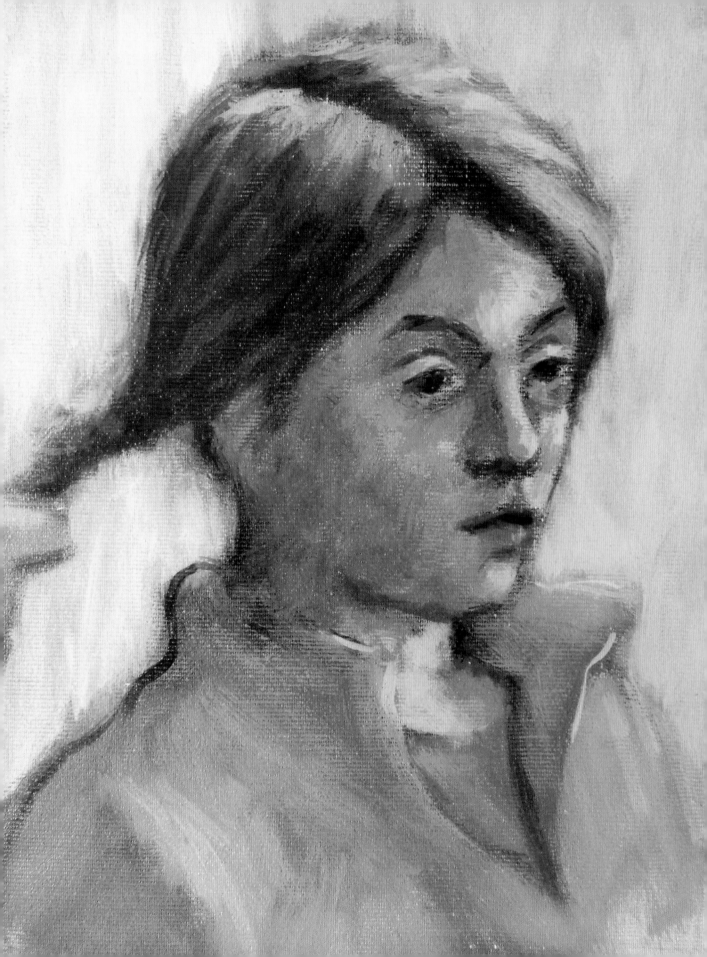

INTRODUCTION

One of the greatest artists of the nineteenth century, Edgar
Degas was a friend and associate of the Impressionists, but
followed his own distinct and original path. A close study
of Degas' methods can offer a tremendous number of lessons
that will be of use to both practitioners and lovers of art alike.
Degas experimented with technique and combinations of
materials with an almost scientific rigor; although he rarely
taught during his lifetime, his numerous versions of particular
images and variations of different techniques provide endless
opportunities for learning, and stand as lessons in their own
right. His approach to painting (which he described as "a series
of operations") was a marriage of a traditional training and
an exploration of new and innovative ways of handling the
medium. He was also modern in his choice of subject matter:
he sought the beauty in the everyday scenes around him,
focusing particularly on the human figure in action. Degas
worked with particular themes—the ballet, women bathing—
and through careful observation and investigation, he built
up a thorough knowledge of each of his subjects.

This book provides a practical introduction to Degas'
approaches to drawing and painting by demonstrating some
of the key ways in which he developed his works. With step-
by-step tutorials exploring his methods, you will gain insights
that will enrich your enjoyment and your understanding of
Degas' work, as well as providing valuable lessons that can
inform your own artistic practice.

INTRODUCTION

Degas was above all a graphic artist who loved to draw with paint and later predominantly with pastel. He admired the techniques of the Old Masters who built up layers of oil paint over a tonal underpainting, but was frustrated by the slow drying of the medium, which inhibited his creative flow. He experimented with using chalk pastels in a way that resembled the Masters' painting techniques—starting with a charcoal under layer and building up pastel in broken layers of color, creating subtle textures and harmonies.

With oil paint he investigated approaches that either accelerated the drying time or else allowed him to build up layers of paint in a single session, while still wet. Scraping down the wet oil paint surface with a palette knife smudged and softened the image, but also forced the paint into the weave of the canvas and therefore made it possible to float a second layer of paint on the surface of the threads of the canvas without the two wet layers mixing. This softening and redefining allowed Degas to lose and find the edges of his figures and gradually define in a selective way. Later in the oil-painting process he would add final emphasis with a thin sable brush, introducing lines at various points here and there.

Given his curious nature, combining different materials and techniques came naturally to Degas. He was one of the first established artists to experiment with and to exhibit his work in mixed media; again reflecting the Old Master approach, he worked with chalk pastels over black-and-white monotypes. The textured surface generated by monoprinting gives instant atmosphere, and each step in the printmaking process can offer new discoveries; for example, the reversal of the images was just the sort of transformation that Degas enjoyed—the mirror image provided a new permutation.

Each of these different media and techniques will be explored and broken down into clear stages. There was something of the scientist in Degas, and his experiments in drawing and painting in their various stages of completion provide a huge amount of data for us to learn from. The following chapters will focus on pastel, oil paint and mixed media, with different sections describing and demonstrating Degas' approaches. Many sections are accompanied by a step-by-step Masterclass, in which the development of a particular image is clearly demonstrated. At the end of each chapter a series of exercises are suggested, which are intended to give you some practical experience of the processes by which Degas evolved his work.

Before illustrating and emulating his many approaches to different media we will look closely at some of Degas' masterworks in order to analyze and articulate his distinctive methods. The points raised as we examine how these images came to completion will be repeated and revisited in each of the chapters, as we endeavor to show how the master's techniques can be employed in our own work.

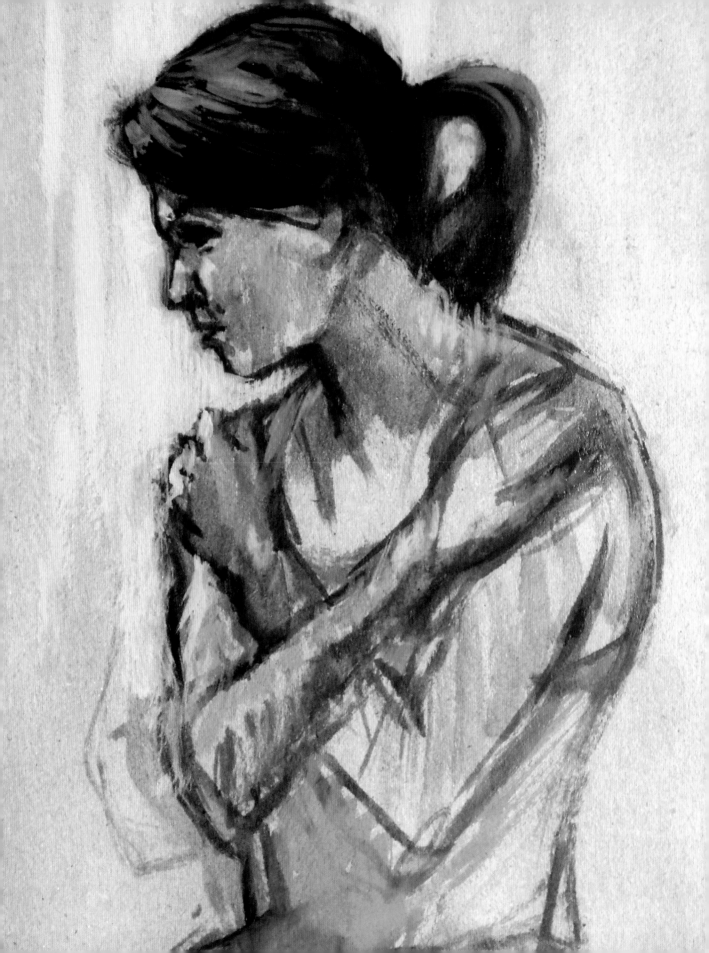

CHAPTER 1: SETTING UP YOUR STUDIO

In this chapter the basic materials required for drawing and painting in the manner of Degas are outlined, and guidance is offered on the different sorts available and how your choices might be determined. You will find these materials referred to in the Masterclasses and Exercises sections of the relevant chapters, but you may find it useful to refer back to the fuller descriptions and explanations offered in this chapter when making your preparations to work.

You will also find advice on organizing your work space; how you might equip it and arrange it—whether you have a dedicated studio space to work in, or just a stolen corner of your home.

PAPERS

Off-white or tinted paper tends to suit pastel work best. Papers designed specifically for pastel are available in different colors, usually neutral grays and browns from a light to middle tone. These tend to have a particular manufactured and repeated texture to the surface. They can be expensive and therefore may be quite inhibiting for first attempts with the medium. It is probably a better idea to try inexpensive papers such as sugar paper or cheap card, especially when you're starting out. You will feel freer to experiment—and even to fail! It is well worth having a range of colors and tones, but stick to muted colors to start with. When building up several layers of pastel with fixative applied in between, thicker or heavier paper is preferable as you will need something more durable that can take a bit more punishment.

Tracing paper has a wonderful smooth surface—yet with enough tooth to catch the pastel—and was Degas' preferred drawing surface for pastel. It can also be bought according to weight or thickness. I laid my tracing paper over a sheet of cream paper (below right) so that I was then able to work on a light, but off-white background.

CHARCOALS

Willow charcoal (below left) was Degas' favored drawing material. It comes in a variety of thicknesses and they all have their uses, so be sure to have some supplies of each. Charcoal is a pretty cheap and humble product, but it can vary in quality, so it is worth paying a little extra for the better product.

ERASERS

Plastic erasers are excellent for carving into willow charcoal and lifting out light in a drawing—putty erasers can also do this and be shaped for the purpose, but they tend to smudge. I find a plastic eraser cut to a point gives a much cleaner and crisper mark.

PASTELS

Degas worked with soft chalk pastels. A whole variety of brands and qualities exist. The very cheap ones don't contain much pigment and resemble school blackboard chalks. You can also find very high-quality pastels, but they tend to come at a price that can make you too afraid to use them! Chalk pastels vary in softness and it is worth trying a few kinds to see which you prefer. The softest will almost dissolve onto the paper as you make contact, while Conté crayons are far harder and will produce a clear line even with a lot of pressure applied. Again, it is worth having a range of pastels as you will find particular uses for the different degrees of softness; when you are layering color, for example, the soft pastels can be applied loosely, perhaps with the side of the stick in the early stages, while the harder pastels will be ideal for the final, emphatic marks that might define particular parts of your drawing. It is also worth buying pastels in sets, with a good number of colors—perhaps 30 or so. You probably won't use them all, but you'll find that you will need a combination of a few bright, colorful sticks, some neutrals and muted colors, and some in darker colors.

FIXATIVE

When you are starting out, hairspray is a cheap alternative to fixative. Proper pastel fixatives are more expensive, but will no doubt make your work last longer, so they are worth investing in once you become happier with your results. Some cheaper fixatives have a foul smell, and it is important to be aware of ventilation whenever using chemical spray—you may want to wear a mask to protect yourself from the fumes. The pre-aerosol can method is still available: blowers can be bought and used to spray on various concoctions of varnish.

SETTING UP YOUR STUDIO
Materials for Working in Oils

CANVAS

Canvas comes in different weights and grades of roughness. For quick experiments and studies it is a good idea to use pre-primed canvas bought on a roll. This can be cut to size and stuck to a board for working—just as you might do with paper for pastel or drawing work. This will make you much less inhibited about experimenting. Larger pieces are best done on unprimed canvas, stretched on wooden stretchers and primed with two or three coats of gesso. However, this is a long, laborious process, so best saved for a point when you are more experienced in handling oil paint and have some clear ideas about the particular piece of work you hope to produce. Alternatively a compromise is to buy ready-stretched canvases. Their quality will be reflected in the price, but cheaper products will do if you are just trying to build up your confidence and experience.

PAPERS FOR ESSENCE

As will be seen later on in Chapter 4, producing the *l'essence* oil paint that Degas often worked with requires using a sheet of blotting paper in order to leach out the oil from your tube colors. Once you have a supply of the transformed paint, you will need a primed surface to apply it to. The approach can involve painting in a broken and translucent way, so that some of the background color is visible between the painted marks—hence a variety of colored papers and cards will be useful in exploring this effect. If you wish to prime your papers, but don't want to lose their color, then rabbit-skin glue size—which is transparent—rather than the opaque white gesso, can be used to seal the surface of the paper.

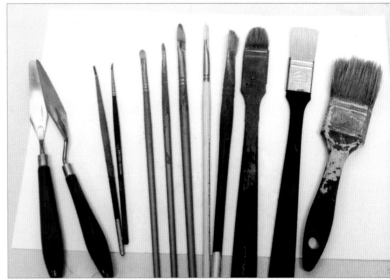

OIL PAINTS

These are available in student quality or artists' quality. The former are cheaper and of inferior quality, but as the name suggests, they are intended for the apprentice and are perfectly acceptable to use when starting out. In the examples in Chapter 4 I work with the following range of colors: titanium white, lemon yellow, cadmium orange, alizarin crimson, ultramarine, coeruleum blue and viridian green. Others can be included to taste—but a lot can be achieved with those listed here and they make a good base to start from. I recommend mixing your own darks and neutrals from these, such as blacks and browns, but some artists prefer to have a few earth colors such as burnt umber or raw umber ready mixed.

The preparation of your palette of mixed colors is essential. Rather like the box of pastels, you will need some stocks of the main colors—often divided into a darker and a lighter version of each color—that can be reached for without the interruption of having to stop and mix. This means that you can begin painting in a general way and once established, the colors can be returned to and either used again or modified and remixed as the painting develops.

BRUSHES & PALETTE KNIVES

For handling quantities of dry oil paint, stiff hog hair brushes are best—they can pick up and deposit a dollop of paint in a direct and therefore more expressive way. They come in different shapes and sizes—I recommend square, long-handled brushes—sizes 2, 4, 6, 8, 10 and 12. These can be supplemented with larger house-painting brushes for making bigger marks. Brushes wear out, especially when you are working on canvas, so be prepared to buy new ones and be aware of the virtues both of new brushes and of old, battered ones.

For diluted and more fluid paint, soft brushes are useful. Thin sable brushes were one of Degas' signatures—at every stage of the painting he added lines with a soft brush that could be brought to a thin point with diluted oil paint.

Palette knives are also essential for mixing colors and the preparation of the palette. They come in trowel or butter knife form—use whatever helps you mix quickly.

OIL/TURPS/MEDIA

In the description of oil painting techniques, you will find that linseed oil has been recommended to be added to your paint to increase its fluidity and even transparency—it will also slow down the drying of the paint. Turpentine, or turps, is traditionally used to thin oil paint and to clean brushes. Many artists start their paintings with a fluid product made from paint diluted with one part linseed oil and two parts turps—by the end of the painting this has increased to 1:1. Other synthetic media can be found, including those that increase the flow of oil paint and also speed the drying of the paint.

SETTING UP YOUR STUDIO
Materials for Mixed Media & Printmaking

The simple monoprinting technique described in Chapter 5 requires a few extra pieces of inexpensive equipment.

PERSPEX

The plate that you make the monotype on can be any smooth surface onto which ink can be applied and wiped cleanly off again. Clear Perspex has the advantage that when the plate is held up to the light you will get an impression of the image to work with as the process develops. Sheets of acetate can be used in a similar way. A4 is a good size to start, but you may wish to experiment with larger and smaller sizes.

INKS

The inks required for this process are special block-printing inks, which have a particular viscous consistency and a slow drying rate. Water-based inks are fine for beginning with and are easier to clean up than the oil-based product. The inks come in various colors; however, Degas did almost all his monotypes in black, presumably with the intention of layering color on top of most of them.

ROLLERS

A couple of printmaking rollers should be enough for this simple process. It's very useful to be able to keep one for rolling out the ink and another, clean roller for taking the imprint onto paper.

PAPERS

Newsprint is a good paper to use for your first attempts, as it prints very well and sensitively. As you become more versed in the technique you will probably want to swap to more robust cartridge papers that will be strong enough to withstand subsequent layers of pastel and fixative.

MARK-MAKING IMPLEMENTS

A great variety of subtle marks can be made by dragging a piece of rag across the ink with your finger. These can range from almost completely wiping the ink off, leaving a grainy brush mark-like effect, to leaving most of the ink still on the plate, but giving it a faint texture spreading in a particular direction. Rags can also be scrunched up and used to make broader sweeps across the ink—good for backgrounds such as floors and walls. The same rag can be dabbed and pressed into the ink to generate other textures. The end of a brush handle can be used to scratch out lines. Mounting board can be cut into small pieces and then used to scratch a line into the ink, or even to squeegee the ink across the plate for another type of effect. Sponges will allow for softer, smudged marks, and of course any of the above can be combined for more complex effects. The secret is to experiment and to take lots of impressions of your different approaches so that you can quickly learn to predict the outcome of a particular technique in the final print.

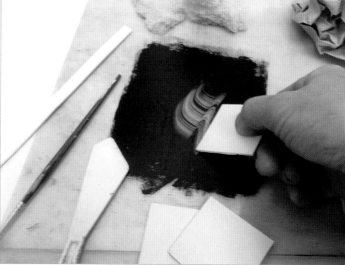

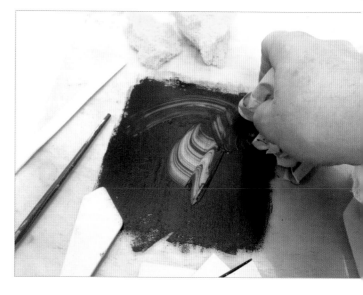

PALETTE

It is important to have a decent-sized surface on which to mix your paints so that you will be sure to mix enough paint to work with. Some artists use a sheet of glass laid over a white surface for their fixed palette, or a piece of white Formica. These can be easily cleaned of mixtures at the end of each session. It is worth mounting the large palette onto a wheeled piece of furniture if you can, so that you can move it easily from one working area to another. You might also have a smaller hand-held wooden palette onto which mixtures can be transferred for working close to the painting.

EASEL

Some artists prefer to work directly onto a wall—I like to take pieces of work on and off the easel and work on a number of pieces during the course of a day. Whichever you do, it is essential to be able to stand well back from your drawings and paintings as you work, in order to clearly and objectively see what you have just done.

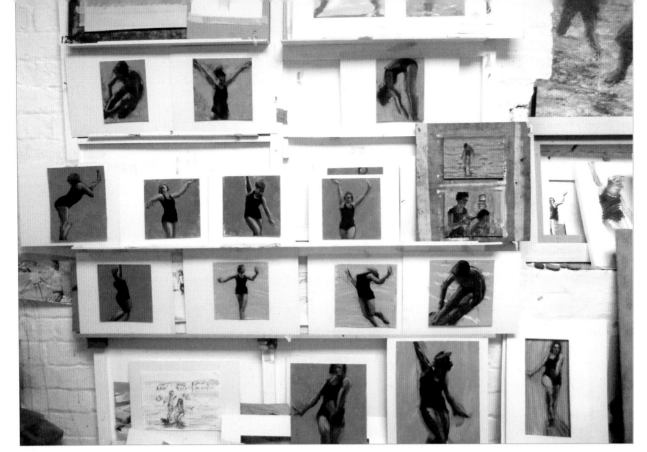

DISPLAYING WORK

One of the most important benefits of having a dedicated work space is the possibility of displaying your work while you are deciding what to do next. A crucial element in the artistic process is that stage when you do nothing. Often it is time—or the time to look without taking action—that helps solve many painting conundrums.

You will find that many of the approaches described in this book refer to the idea that Degas was a master of doing less, working with fresh, economical marks. It will have been those times when he was able to consider his work, left where he could see it, sometimes out of the corner of his eye as he worked on something else, that he probably made his best decisions. Another French artist, Édouard Vuillard, once said that an artist's most important piece of equipment was his armchair—from which he could view his unfinished work and consider how to resolve it.

In my studio, as well as bare walls where I can hang and display work, I also have a series of shelves on which smaller works on paper and boards can be placed.

SETTING UP YOUR STUDIO
Studio Space

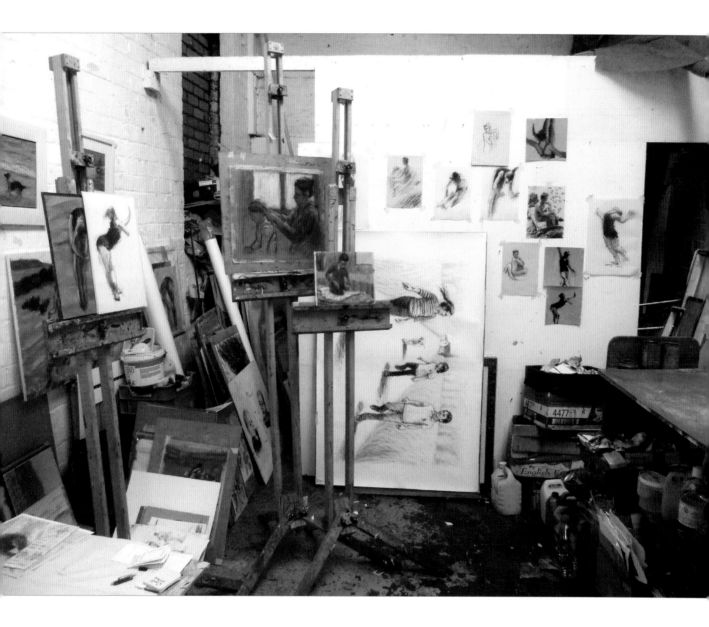

It's great if you have a dedicated studio space where you can set work up and leave things in progress. Oil paints, inks and pastels are all messy and sometimes smelly, and if you have to tidy things away at the end of each session it can become harder and harder to ever get started the next time. Work that is left in progress, especially if left while you reflect on your next course of action, can easily be taken up again and quickly resolved—provided it is there within reach, waiting patiently for the artist to be ready. An ideal studio might have somewhere to store papers and finished work, good, consistent natural light, space to prepare your paints and clean your brushes, room to stand well back from your work and walls to display your work on.

However, it should be said that, particularly with pastel, there is a lot that can be done on a small scale and in a small space—and it is much better to work small than to not work at all.

STUDIO EXTRAS

It is extremely useful to have good storage in your studio, where supplies of paper and finished, unframed work can be kept flat. A plan chest (above), which has large, shallow drawers, is ideal if you have enough space.

Old telephone directories are useful for cleaning your palette knife when mixing stocks of color (above right).

THE SMALL STUDIO

If you've had to steal a corner of your home to work in, it is possible to achieve a lot in pastels and drawing on a small scale. A selection of essential materials is illustrated at right: charcoal, eraser, pastels, papers, a drawing board, masking tape and fixative. The issue of having the room to step back from your work can be easily solved if you have a digital camera and can photograph and print each stage out on a small scale, to be pinned up somewhere like your kitchen where you can consider it regularly as you do other things.

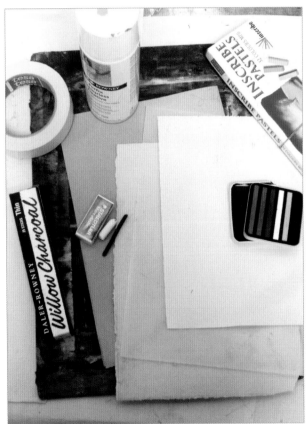

SETTING UP YOUR STUDIO
Subject Matter & Models

Most of Degas' work was figurative and the examples explored in this book are all based on observation of the human figure, both nude and draped. There are different approaches to gathering this point-of-reference material, which you will need to produce drawings, paintings and prints. Degas favored training the memory and not working exclusively with the model in front of him. He did plenty of rapid drawings from his models, but also worked from these drawings when producing other drawings, paintings and prints. He once said that his ideal art school would have the model on the ground floor and the students on the floors above, according to their experience—the most experienced on the upper levels, where they would be required to work increasingly from the memory of their sessions in front of a live figure. Degas' own approach was grounded in a profound observation of the figures he drew, but supplemented and strengthened by his recollection of the essential qualities, or the essence, of his subject.

WORKING FROM LIFE

Your model will need a warm, private space in which to pose. They may need their own heater, especially if they are nude. You will need good, directional lighting that you can manipulate—simple spotlights that can be clipped onto a surface/wall/ceiling are really useful. Otherwise it may be possible to pose your model near a window so that there can be a clear light source. Sometimes it is helpful to have a podium or a box for your model to stand on. Depending on your particular theme, props and pieces of furniture such as benches and stools can be useful. To a certain extent you and your model are engaged in a game of roleplay or theater—so be creative about how you set the scene and what you don't have to hand, make up. If you can work out what props will best identify a particular theme or narrative—for example a bench and a long mirror for a dance studio—then your painted conceit will be all the stronger. If the relevant props are not available in your studio you can attempt to contrive them, either with bits of furniture or from memory.

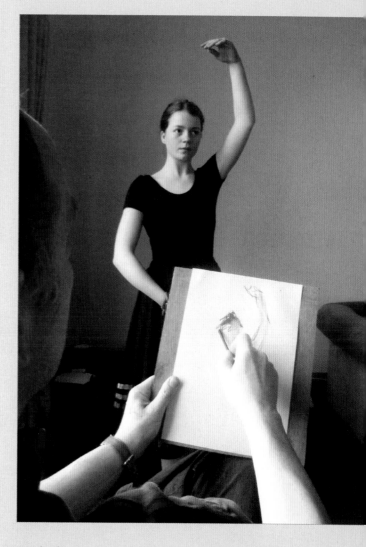

For the dancer pictures in this book I contacted a local dance school and several students were happy to pose. This was advantageous for everyone: it was good experience for the dancers, and particularly beneficial to those drawing them since they knew what movements to make and poses to strike, and, as dedicated dancers, they were able to bring a variety of costumes to wear.

WORKING FROM PHOTOGRAPHS

Degas worked at the beginning of the era of photography and was himself interested in experimenting with this new technology. If you want to work from photographs, the key thing is to light your models well or choose well-lit photographs. In this way your photographic reference will be clear and easy to read—you will be able to make sense of both form and space. For the images of the woman brushing the girl's hair on page 96–99 I took photographs of my wife plaiting our daughter's hair at home in the kitchen. Here, photography had the advantage over working from life in that I was able to capture an authentic scene, which wasn't posed but rather a genuine event.

WORKING FROM DRAWINGS

Often the best approach, indeed the main approach taken by Degas, is to paint and to develop pastel works directly from drawings. Drawing, particularly when done quickly, is a process of selection and your drawings will tend to contain a summary of the most essential aspects of your subject. The more you go through the process of developing drawings into paintings and pastel paintings, the better you will become at recognizing what is essential about your subject and also what interests you in particular about a pose or a theme.

Rather than painting directly from photographs—which basically contain too much information—it is more valuable to make a quick sketch from the photo, extracting the most essential information, and then use these drawings as a basis for any paintings or pastel paintings. Then you will find that you are getting directly to the essence of your subject, and that observation will be supplemented by memory—and the art of selection will have begun.

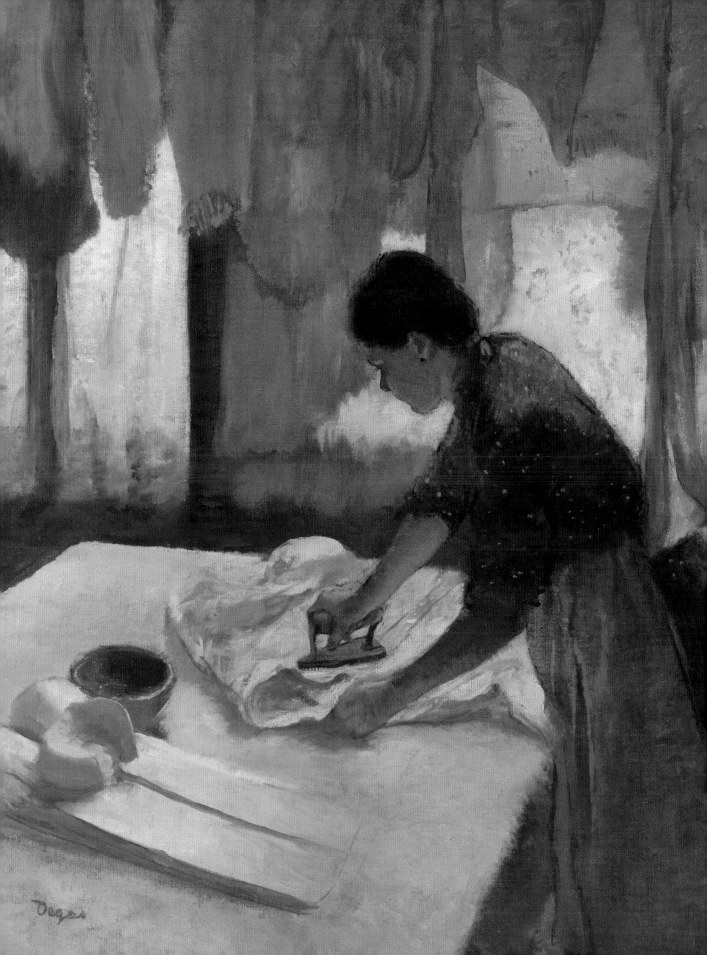

CHAPTER 2: DEGAS CLOSE UP

Degas was a realist painter who developed from historical painting to becoming a painter of contemporary life. He sought the beauty in the everyday themes of working people, the horse races, the ballet and women in the privacy of their toilette. Most of his work was exclusively figurative and reflected city life. A friend of the Impressionists, he shared many of their preoccupations with color, abstraction and the modern urban experience—although his preference was for working in the studio and he advocated working from memory as much as possible. To this end he developed a profound knowledge of his subjects—drawing jockeys and horses in all combinations of pose and scale; observing ballet dancers on stage and in the rehearsal room. He researched and understood the posture and characteristics of a dancer adjusting her costume, or a woman leaning on her steam iron; he identified the best poses to exemplify this, and then simplified and strengthened them. He stood on the threshold between tradition and modernity. "Two centuries ago," he said, "I would have been painting 'Susannah bathing', now I just paint 'Woman in a Tub."

This chapter we examine a number of Degas' works and discuss particular aspects of his approach. Certain themes such as composition, contour and color will be central to the practical demonstrations of his technique in the following chapters, and in the next few sections we will investigate some of the respective features that characterized his masterworks. Hopefully it will be rewarding for you to move from the examples of Degas' work chosen here to the deconstructed processes outlined in the coming chapters on oil, pastel and mixed media, and make the necessary connections between them.

THE DANCE LESSON

Degas was spectacularly inventive in his approach to composition. His working methods demonstrate a flexibility and willingness to adapt and modify his compositions (for example, adding extra pieces of paper to change the format of a piece and radically alter the image). Movement characterizes many of his subjects—the dancers, the racehorses—and this was in turn emphasized by his choice of composition. For instance, the long, wide, double-square format with figures arranged along a diagonal from one corner to another would enhance the sense of movement of the figures arranged within it. He was also interested in photography and the accidental cropping of figures in a snapshot. This cropping tended to give a more natural or authentic arrangement of people—much more like real life, and therefore more dynamic and unpredictable. In these moving subjects he also employed a wonderful approach to the pattern and rhythm of repeated figures, whether dancers in a line on the bar, or horses in a line at the start of a race.

The Dance Lesson (1879), right, illustrates many of the above points. The format is long and narrow, and the figures are spread out from left to right (the direction in which we "read" a painting), from the bottom left corner up to the top right corner. These figures get smaller in scale as we look along the painting, decreasing in size as they get farther away. Hence the movement across the painting is also a movement away from us, deeper into the picture plane. This is further emphasized by the cropping of the first seated dancer in the foreground—effectively she is so near that she doesn't even fit into the picture frame. Meanwhile, off in the distance another figure at the opposite end of this line is also cropped severely so that her face and hands are all out of the frame. Each dancer is turned in a different direction from the next— there is almost a spiraling motion from the first through to the last. The architecture with a dado line runs diagonally straight up the painting—but the figures themselves create a broken line with varying distances between each group, creating a more interesting and natural rhythm.

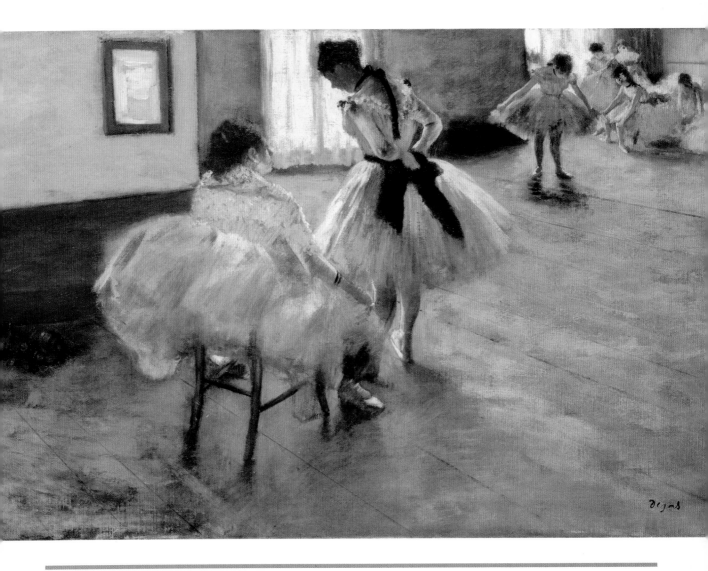

COMPOSITION

- Degas' inventive compositions were often based on unusual formats. Try drawing on square papers, or long narrow double squares. By choosing unusual formats, your compositions will often surprise you as you attempt to deal with different parts of the design.
- Carefully consider the placement of your subjects within the frame, and avoid the obvious. By cropping out some features, Degas' compositions appear more natural and less contrived.

- It is instinctual to try to contain your whole subject within the edges of the frame, so if you're struggling with this try intitially photographing your subject deliberately cropped and work from that.
- As well as the placement, consider how the position of your subjects reflect the theme or mood you want to convey. So in the above painting, the spiraling motion conjured by the positions of the dancers immediately makes you think of the movements of a dance.

DEGAS CLOSE UP
Anatomy

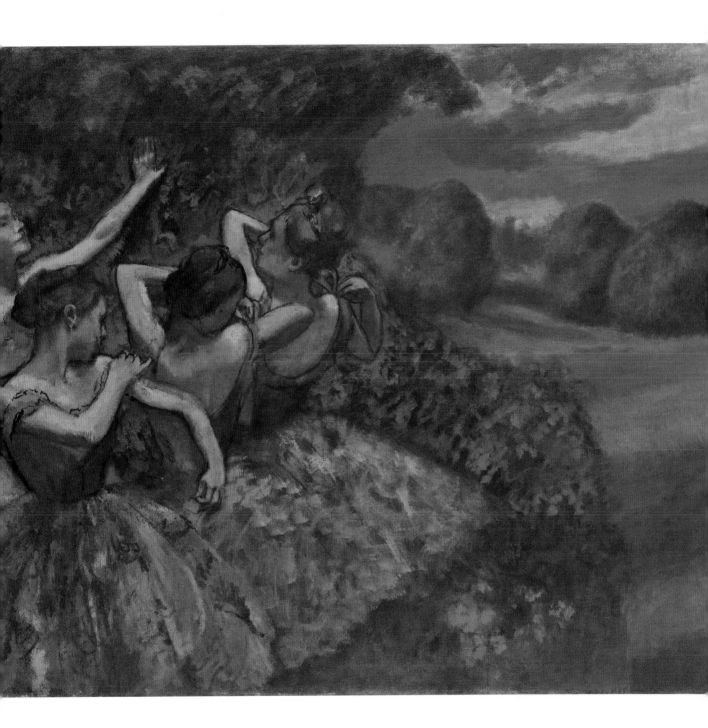

THE FOUR DANCERS

Degas had a thorough knowledge of anatomy, a knowledge that was highly developed and attuned to the characteristics of different human activities. Studies exist of dancer poses drawn without clothing in what seem to be an investigation of the anatomical consequences of certain actions and movements. These same figures reappear in more developed pastel and oil paintings, clothed and therefore with only parts of their anatomy showing. This illustrates Degas' in-depth approach to his human subjects. The pastel paintings on the theme of bathing women or women drying themselves after a bath are often constructed with charcoal outlines along the arms and shoulders, which gradually disappear under layers of color. With each new step he would often restate the edge of an arm or a leg and continue the buildup of color. The accumulating lines hover beneath the layering and seem to add a sense of movement—of life—to the person. His critics, however, were not so convinced and suggested that these repeated attempts at defining anatomy were evidence of Degas' uncertainty—that he had no idea exactly where to place the limits of a figure. Degas gracefully accepted their analysis, saying that nothing could describe his doubt as he drew better than that.

Degas' beautiful draftsmanship is obvious in his earlier, more finished works such as *L'Absinthe* (see page 32), but he demonstrates a more sophisticated grasp of anatomy in his later, looser, and more abstracted works, such as *The Four Dancers* (c. 1899), seen left. The figures overlap and obscure parts of each other; each is cropped at the feet, at least, and more so for the two figures on the left. However, what appears of their heads and arms is absolutely precise, although loosely indicated. The nearest figure turns her head to her left as she adjusts her costume. As the head turns one way, the neck muscle on the other side relaxes and appears as a distinct line from the ear down to the top of the sternum. Degas has modeled the shadow and light sides of the neck, and the meeting of these planes defines the sternomastoid muscle. The central figure of the group of three, with her back to us, also stretches round to deal with her shoulder strap. This is a good example of Degas repeating the same pose, but showing it from another angle. As she leans back the light falls on her shoulders, but only as far as the horizontal line running across each of the shoulder blades. These are the protrusions from the scapulae to which the muscles of the back attach. All this clearly demonstrates that Degas might draw and paint loosely and abstractly (or in a simplified way), but he is always precise.

AFTER THE BATH

There is one further point that is perhaps worth making before leaving the subject of anatomy. If you examine the pastel painting *After the Bath* (1885), right, you will see the familiar repeated edges, particularly to the raised arm that dries the woman's neck. This searching for the limits of the form, as already mentioned, also creates the sense of an almost animated sequence of movements associated with the activity of drying oneself.

The crucial point about artistic anatomy, as opposed to medical anatomy, is that what matters is the way forms and shapes alter according to what the muscles are doing. As Degas builds up layers of color and changes his mind with each attempt, or alters the emphasis with each layer, there is a wonderful contradiction of sharpness and blurring, which represents the living breathing subject to an extraordinary degree. All this movement in muscle and bone is also echoed and repeated in the towel and the curtains.

ANATOMY

- Hone your knowledge by sketching from life or from photographs of different poses, considering which features of the anatomy are coming into play in each movement. When you feel comfortable, try working from memory.
- Practice drawing your model with charcoal lines and hatching in blocks of tone or value. Then smudge the drawing by dabbing it with a rag—this will play down and bring together some of your observations and simplify the figure. Then reintroduce some detail, but less than before—just the important lines, shapes and edges.
- Tracing paper is particularly good at allowing you to soften an image and then redefine it—both with new lines as well as using an eraser to clean charcoal off completely.
- You can also use tracing paper to quickly repeat figures, by tracing over a form and laying down its reverse on the page, perhaps changing a feature here or there.

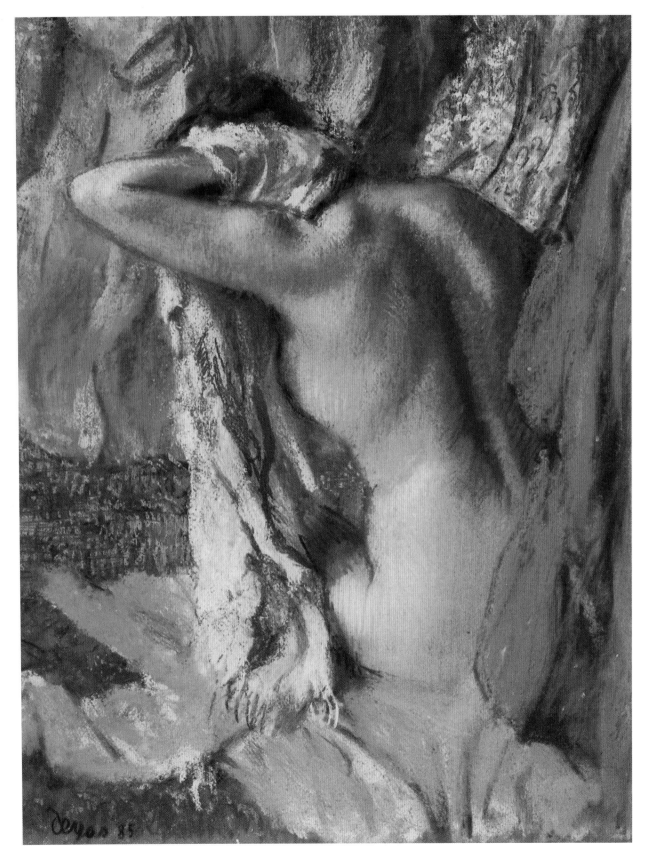

L'ABSINTHE

Degas is perhaps most celebrated for his draftsmanship—many of his methods were chosen specifically because they allowed him to work with line and contour. This line was often calligraphic, like handwriting; indeed his mark-making could sometimes resemble Chinese lettering. Pastel became a natural medium for this draftsman who wished to draw with color: "A colorist with line," was how he described himself with pastel. Degas exploited the full potential of the pastel mark—washes with the side of the stick and a whole lexicon of scribbles, dashes, hatchings and dots with the tip. When Degas painted with oil paint the desire to draw was aided by working with a thinned fluid mixture, often applied to a smooth, absorbent surface. This was particularly the case with *peinture à l'essence*, where the modified oil paint was diluted and painted onto paper or card.

Over the course of developing a pastel painting, Degas built up layers that allowed him to lose and find edges as he worked, and ultimately to restate lines and contours. Similarly, when working in oils, his use of scraping down the still-wet surface softened and smudged sharp contrasts and left him scope for returning to add line and contour to the parts of the painting he wanted to emphasize. He appeared to use line less in the early stages of his later oil paintings, building up textured areas of pattern and color. Nevertheless, the calligraphic line would eventually be added toward the end of the work, in a selective and highly abstracted way.

L'Absinthe (1876), right, is a carefully crafted example of Degas' early oil technique. It is striking in its unconventional composition—a dynamic movement zigzagging up the canvas toward the two unhappy figures, brought to their desperate state by the alcoholic beverage of the title. The work has a smooth finish, likely with plenty of scraping down between built-up layers of thin paint. The woman's face is the most highly finished part of the painting, and consequently draws most of our attention. Other areas, including the man's face, are relatively loosely defined and one can see *alla prima* painting where the colors have mixed on the canvas. The fluid arrangement of the composition suggests a careful drawing out of the design—probably made in a dark, thinned ink of alizarin and viridian—with each figure, the space between them and the interior of the room clearly defined with an initial line. Over a number of stages different parts of the painting have been built up and scraped down. This process will naturally lose and find edges of the forms of figures and the furniture. The outline appears in places as a final statement of emphasis. Behind the woman's head and running down her back, a black line has been painted with a thin sable brush that skips and jumps down the neck, along the shoulder and back. This particular sable line is a common feature in Degas' figures. Other, fainter lines have been used to define the folds of the clothing and the contours of the tables. These softened lines have either been lost through more translucent paint being dragged across them with a dry brush, or by scumbling, in which a small amount of paint has been spread out over a large area. In other places the softness has been achieved through the dragging of a stiff hog hair brush across the rough texture of the canvas, or of the slight buildup of layers of dry paint. The painting includes almost a history of Degas' evolution as a painter of form—from the more classically modeled woman's face, with subtly contrasting skin tones, to the almost flat rendering of objects such as the glass and decanter, which have been outlined with a broken line.

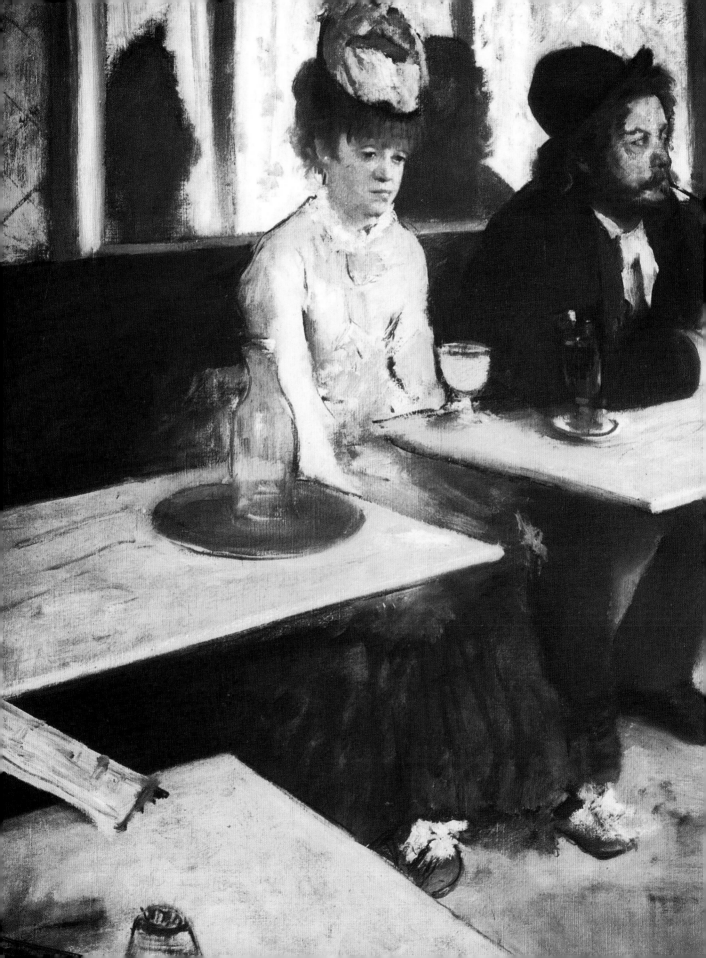

BEFORE THE REHEARSAL

Degas' *Before the Rehearsal* (1880), below, is a pastel painting begun with a flowing charcoal line then layered with pastel color until the contours and outlines disappear, or become broken up by them. In places the clear line remains—along the length of the dancers' legs, for example—while in other places, where Degas wishes to create the softness and translucency of the dresses, for example, he allows the edge to be lost.

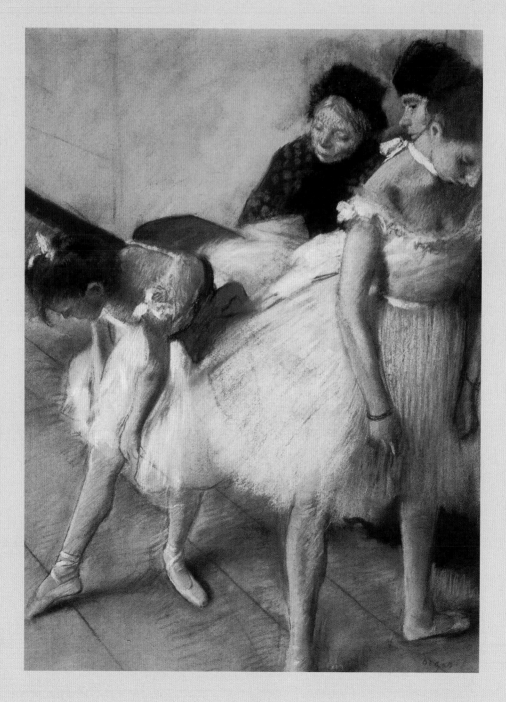

WOMAN IRONING

Woman Ironing (c. 1887), right, has just a few clear lines
that probably would have been made at the final stage of the
painting. There are plenty of other lines buried under layers
of thicker paint, or absorbed into the edges of the different
shapes that represent the figure and its surroundings. A close
examination of the woman's head shows a delicate line running
along the profile of the face. Interestingly, the line changes
color from the edge of the eye, which is blue-black, through
to the nose, which is a red-brown line. The nose has a clear
edge where the color has been filled in up to the line, while
the line of the cheek has disappeared under a dry brushstroke
of highlight on the edge of the cheek. These variations in the
quality of the line suggest layers of paint being built up and
scraped down almost until the lines have been incorporated
into the painted shapes of the picture. There is little final
emphasis in this image through line. It is much more a case
of soft and hard edges being created through layering of
paint, and a fine balance between sharpness and softness
being struck to resolve the image.

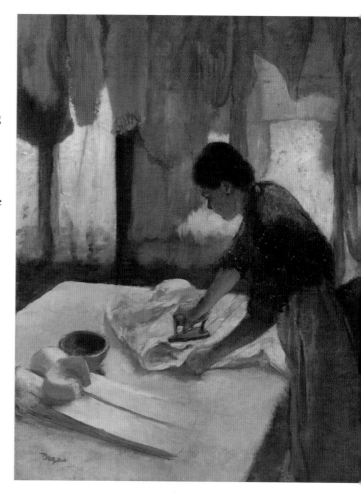

CONTOUR

- Line and contour were fundamental to Degas' vision;
 whether it was the beautiful draftsmanship of the initial
 line drawing of a piece; or the lines added at the very end
 of the process.
- Think of drawing in these two ways in your own work
 —the initial sketch and the final emphatic marks—placed
 with the draftsman's precision.
- Save the lines until later: resist using defining lines until
 near the end of the painting and when you do, paint them
 thinly and even smudge them once drawn out.
- Vary your lines as appropriate to the particular thing you
 are drawing. A gauzy material might have no clear lines;
 the profile of a face might have soft or broken line; a more
 solid surface might be defined by a thicker or harder line.

CAFÉ-CONCERT AT LES AMBASSADEURS

Color is a particular feature of Degas' later work. In his early work it tends to be restrained and the drawing more evident, more significant—demonstrating the influence of Ingres, whom he revered. As his pictures become looser, the color becomes more important and any mark-making is sometimes just a final emphasis with a restated line here and there.

His most striking later compositions are often characterized by rich, harmonious color—but notably achieved through a limited palette, mainly consisting of blues and yellows, with their related grays and neutrals; or pinks and greens, together with different, related browns. Many of his experiments with materials and techniques generated unexpected color combinations and required him to balance and adjust color on color. He once said, "The art of painting is to surround a touch of Venetian red so that it looks like vermillion"— perfectly summarizing what the process of working with color meant to him.

Café-Concert at Les Ambassadeurs (1876), right, is a fine example of Degas' mixed media technique of using pastel over monotype. The process begins with a monochrome under-drawing in black ink. The scene has been conjured in wonderfully varied textures and patterns to represent the architecture of the room, the figures on the stage and the musicians in the foreground. You need to look closely at the image, and particularly to the distant background areas of the pillars and mirrors, to see through the quite-thin layers of pastel to the black and gray ink marks. The line of circular lamps that appear to be outside the window (or possibly reflected in the mirror) has been created by dabbing a finger tip in to the wet ink, leaving a pale gray circle. In most of the rest of the image color has been densely built up and generally hides the monotype—although its presence continues to unify the image despite being barely visible. This is of course very like the monochrome underpainting, or *ébauche*, which was a standard initial stage in the traditional oil-painting process that Degas studied and admired in his close observation of the Italian Masters. In the traditional technique, color was built up on top of a monochrome layer, which held the drawing or composition, but also unified any new colors laid over it.

Color was intensified by contrasting a bright area against more muted versions of the same color. For example, the light on the arm of a red dress in a Titian would be created by a brighter red laid over a duller, or less saturated, red that covers the rest of the arm. This is exactly what Degas has done with the color in the main singer's dress. A slightly thinner layer of chalk pastel has been smudged across the black ink of the monotype in order to create the dull red of the dress's shadows. Where the light catches the lower areas of the skirt and some of the neckline, thicker, more solid pastel has been layered up, perhaps fixed and restated, to reach a more saturated, stronger color. The Old Masters used this particular way of contrasting color to create their color effects, whereas the Impressionists explored the contrast of color by placing complementary colors side by side.

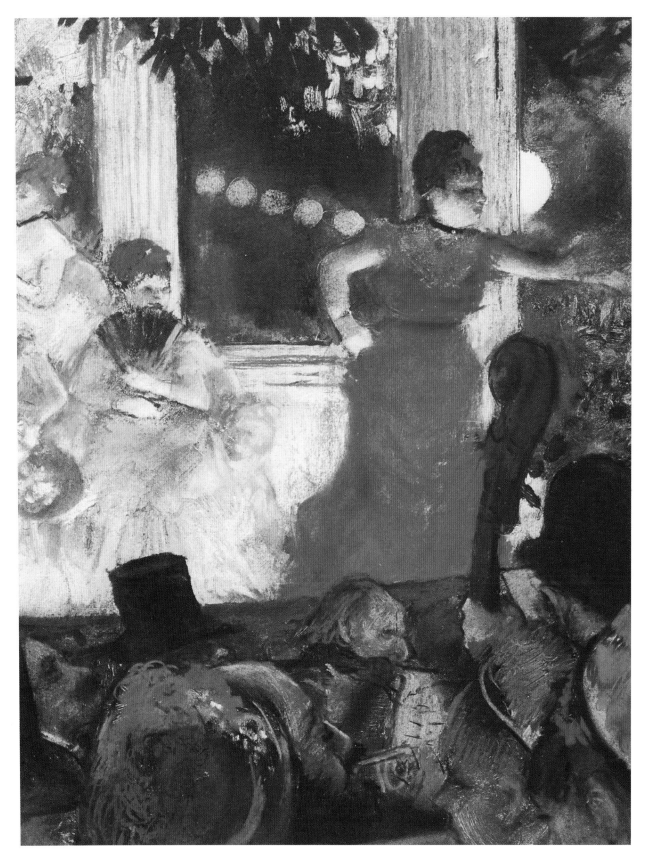

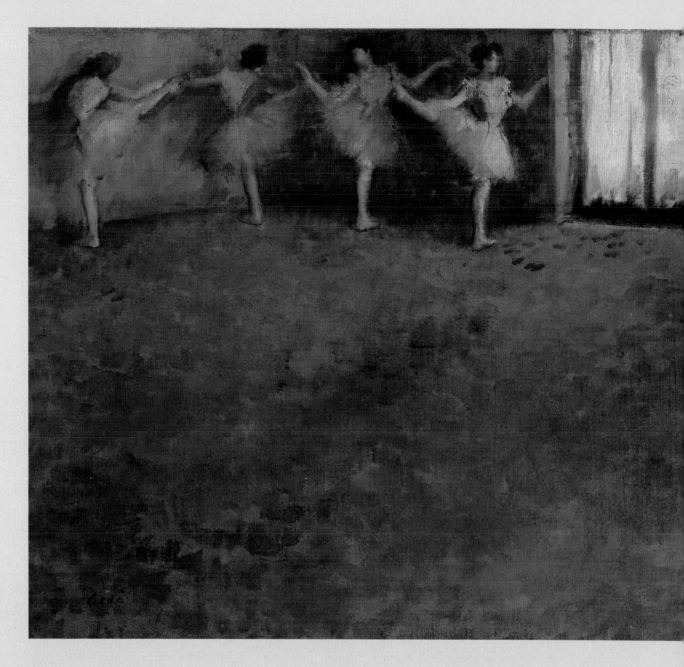

BEFORE THE BALLET

When you examine a slightly later work like *Before the Ballet* (1888), above, you see color used in a way that was typical of the Impressionists. Though you may not see it at first glance, the image is very colorful: in spite of the fact that the dancers are dressed in white costumes in a dull and largely empty interior, there are plenty of different colors at work. When you analyze these colors you can see they can be understood as sets of related colors. The orange-yellow of the walls has been combined with a blue-gray and the dull green of areas of the floor is laid over with pink marks—

quite possibly made with Degas' own fingerprints. These color combinations are essentially complementary—being opposite on the color wheel—and they make each other stand out. This use of color contrast appears in other parts of the picture. Skin is naturally subdued in hue, so in order to enhance the color of the arms and legs and faces, Degas uses both green and red skin tones around a lighter yellow or pale orange. In the white dresses, what could be a dull color effect has been strengthened and heightened by under-painting with dark pinks, then over-painting the middle and lighter-toned areas with a green-gray.

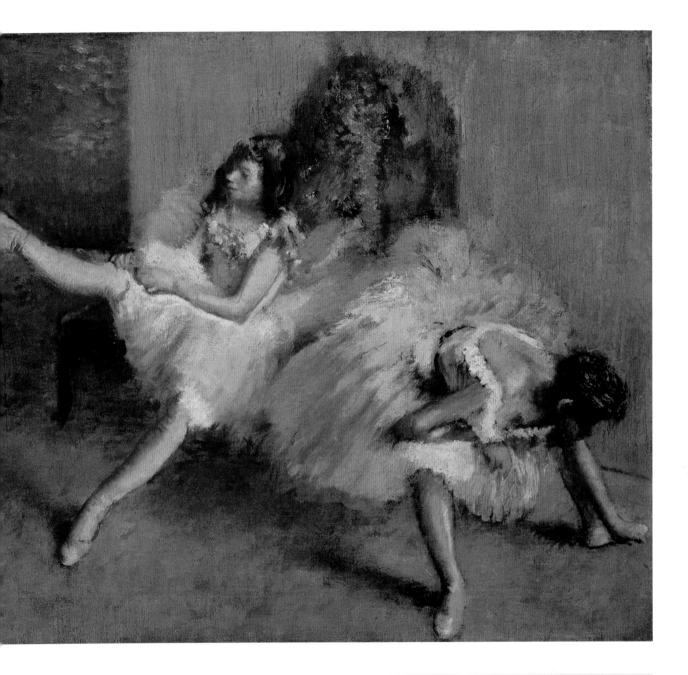

COLOR

- A particular feature of Degas' approach was to use a limited palette, just a few colors chosen for their relationship to each other: complementary opposites, light and dark sets, bright colors balanced with neutrals.
- Complementary colors will make each other stand out; a bright color surrounded by a more muted color of the same hue will be all the more striking.
- Perform your own experiments with color to discover the effects of different combinations, and keep these swatches

as a handy reference, in keeping with Degas' own scientific approach to painting.

- To put these ideas into practice, try working on a pastel piece with a handful of carefully chosen colors using a black-and-white drawing or photograph as the basis.
- Begin a painting of a dancer with only a single blue for the skirts and gradually modify the blue into different lighter and darker, cooler and warmer versions.

CHAPTER 3: DEGAS & PASTEL

Degas was a highly graphic artist who loved to draw at every opportunity—from the start and right up to the completion of a painting. He studied and practiced the traditional process of building up an oil painting from a tonal underpainting, known as *ébauche*, through layers of color to a resolution. But the slow drying of oil paint was a frustration to him and he sought approaches that would allow him to build up layers of color more quickly. One approach he took was to modify his oil paint by leaching out some of the oil content using blotting paper. This new form of the paint, called *L'essence*, would dry more quickly, especially if applied to an absorbent surface such as card or paper. However, chalk pastel offered an even better prospect: Degas could draw in color, apply fixative and draw another layer on top almost instantly.

This chapter explores and tries to deconstruct the pastel painting process that can be observed in Degas' many unfinished and finished works, from the initial flowing line that sought to capture the most dynamic poses of his subjects—searching for both accuracy and movement—through to Degas' inspired approach to composition and his search for the best poses, using tracing paper as a means of exploring different versions of a drawing. We will look at atmospheric tonal approaches and the building up of color, layer by layer, to generate both subtle harmonies and bold, vibrant color patterns and textures.

A number of Masterclasses will illustrate some of the main points about his technique, and at the end of the chapter you will find some exercises that should help you to better understand Degas' method and find ways of applying his working practices to your own work with this medium.

FINDING DYNAMIC POSES

Degas always worked to develop his knowledge of each of his particular subjects, studying dancers in action and at rest. He would select and remember specific characteristic poses for the way they might portray movement—long arms outstretched, for example—or in order to suggest a more private or intimate atmosphere, such as a dancer adjusting shoulder straps on her costume.

Line is ideal for generating a sense of movement, and a continuous line, drawn without taking the charcoal off the page and thus connecting every part of the figure, can generate a fluid, searching contour. The line drawings on these pages were executed in the manner described, in an attempt to identify some good dynamic poses—exploring a pose purely in line can be a very good way of revealing its potential to express movement.

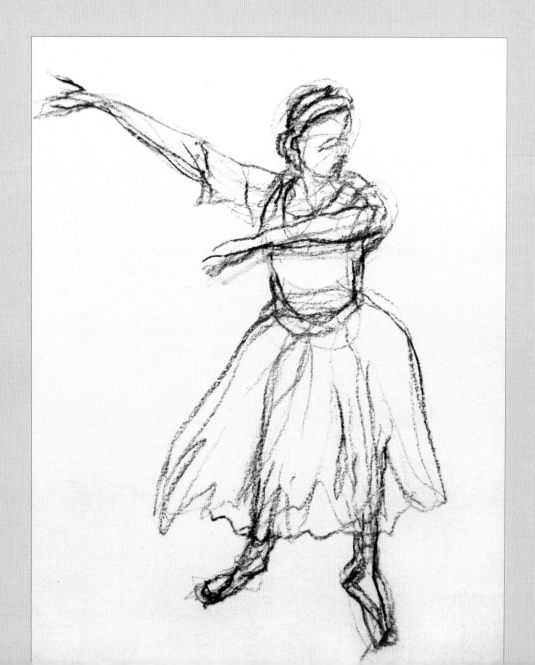

The image at right shows the first stage of the drawing; a single fluid line that not only follows the outside of the figure, but crosses it at shoulders, waist, hem of skirt, etc. In the image on the opposite page, the line is repeated and restated, introducing emphasis and refinement. You are trying to find the key marks to emphasize—these may be the very places you will want to restate at the end of the process, once color and textures have been built up.

The two images below show a similar progression. Degas collected numerous observations such as these and distilled the best examples from them to be developed in his many figured compositions.

Willow charcoal was used for these drawings: this is a wonderfully fluid medium that allows one to draw long, flowing lines. Thin sticks are particularly good for delicate and sensitive initial lines—they will snap, but it is worth the trouble to be able to create what are instinctive and often very eloquent marks.

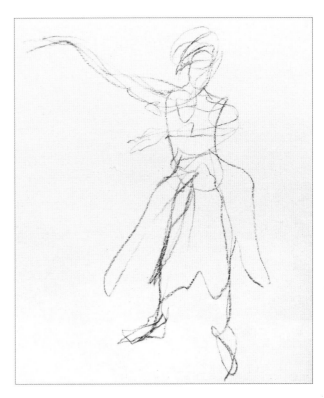

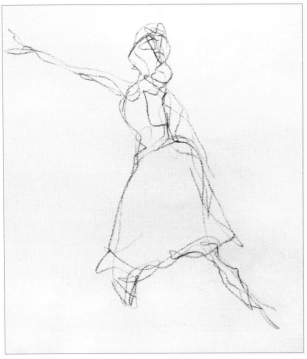

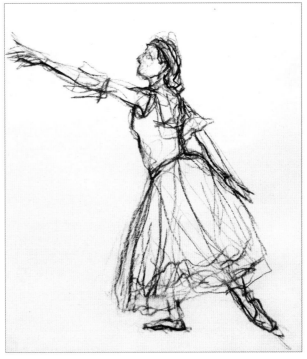

DEGAS & PASTEL
Charcoal Beginnings: Tonal Starts

CREATING ATMOSPHERE

Tone (also known as value) can create atmosphere and works well to strengthen pastel colors, especially darker pastels. When laid down underneath the (sometimes) pale colors of chalk pastels, it can increase the contrast and make an easy bridge from tone to color. Degas often built up a rough layer of charcoal shadow or dark shapes that, once fixed, could be refined with careful placing of color marks in pastel on top. Sometimes quite large areas of black and gray would be transformed with very broad hatching of pastel across them. In order to achieve these effects it is useful to try drawing figures without lines—hatching or scribbling shadows and silhouetted shapes.

The first image (above) shows the figure of a dancer adjusting her hair in the mirror—no outlines or contour lines are used, rather a diagonal hatching or scribbling. Looking at your subject with eyes half closed can be a helpful approach as it simplifies lights and darks into shapes that can be built up with the hatching.

In the second image (above right) the hatching is gently smudged and the effect is softened: the form of the figures becomes more solid.

In the third image (right) the hatching is strengthened.

A detail in the image opposite shows some brown and off-white pastel laid over the fixed blacks and grays of the hair and dress. The hatching is strengthened further still, and in a more general way, to pull the image together.

DEGAS & PASTEL
Smudging Charcoal & Pastel

Rubbing charcoal into the page in order to smudge it creates a more solid effect to the form of the figure—it quiets down the light surface of the paper and, when fixed, allows lighter (opaque) colors to stand out clearly on top.

In the first image (below left) a dancer is drawn in flowing line; areas are filled in with tone and then smudged. The arms are left smooth, but extra hatching is introduced to the face and hands to liven the surface. This layer is then sealed with fixative, a dark brown pastel laid over the hair, and a lighter brown (sanguine) color hatched across the shadows on the face and hands.

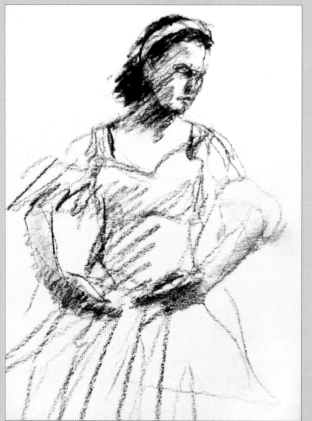

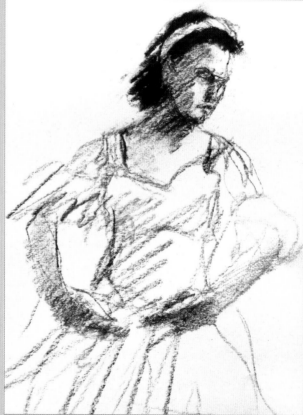

The three images on this page show the same building up of color layers on top of smudged charcoal. The yellow of the dress is muted or grayed by the charcoal under layer, particularly in the areas of shadow. Then a brighter yellow and orange-yellow are added to the lit areas of the shoulders and tops of the arms. Each layer of fixative seals the layer beneath and creates a tooth to the surface of the drawing, which will readily take more and fresher color.

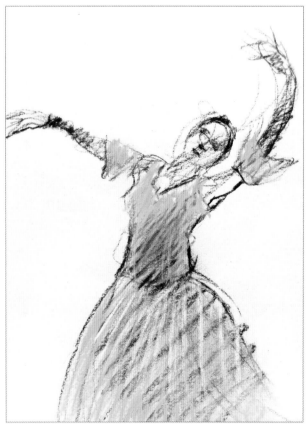

DEGAS & PASTEL
Masterclass: Dancer Seated

1

The dancer is drawn out in a delicate line using thin sticks of willow charcoal. It can be useful at this stage to attempt a continuous line, moving from one part of the drawing to another without lifting the charcoal from the page. Degas often recalled the words of his master, Ingres: "Draw lines young man, plenty of lines…"

2

A tonal pattern of dark and shadow areas is applied with hatched or scribbled strokes over the initial line drawing. It can be helpful to look at the subject with eyes half closed to help simplify this light and dark contrast. This can be smudged and softened with the fingers, and the smudges in turn adjusted with an eraser. This under-drawing can be increasingly refined, or left loose and atmospheric, allowing the refinement to come gradually with the subsequent layers of color.

3

A layer of fixative is applied at this stage to seal the charcoal and provide a good tooth for the pastels to sit on the surface.

4

Pastels are applied loosely, in hatched and scribbled strokes; thin veils in some areas such as the translucent skirt, and more thickly in others, such as where light falls on the surface of the skin. Degas liked to lose some of the charcoal edges by allowing the pastel to spill over them and break them up—at a later stage some lines would be redrawn with pastel, or even charcoal to redefine certain edges.

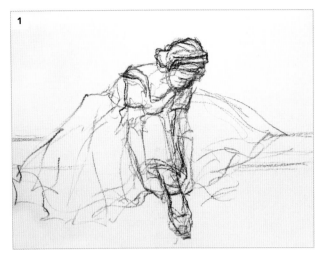

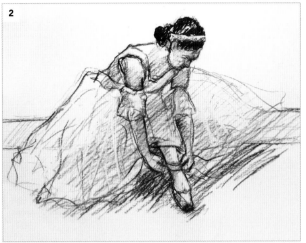

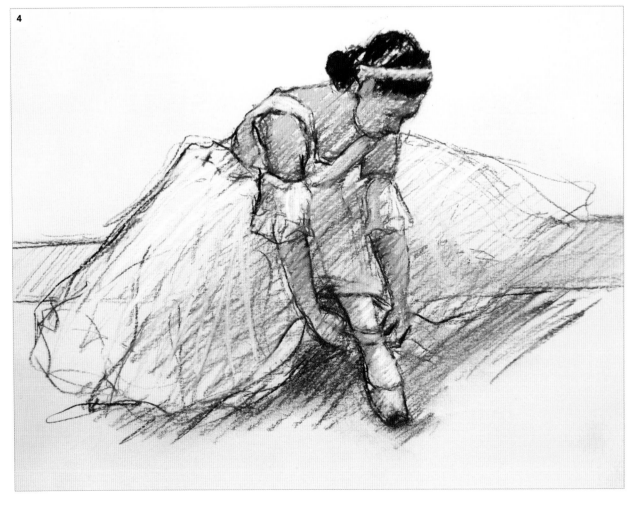

DEGAS & PASTEL
Fixative & Layering of Color

Many artists have used pastels for making color notes for their paintings, particularly portraits, but Degas pioneered the building up of layer upon layer of color. If one attempts to draw pastel on pastel for a prolonged period, the surface of the paper becomes filled and smooth, and will not take any more material. If fixative is sprayed over the drawing, the surface is sealed—coated with a kind of varnish—and more chalk can be applied. Indeed the surface of fixed pastel often has a particularly good tooth and will take the new layer in a fresher, more vibrant way. Hence, chalk pastels combined with fixative can allow for a phenomenal number of permutations of color and mark. Within each layer, pastel can be smudged and mixed on the surface for soft, delicate effects. Then from layer to layer crisp, fresh colors and marks can be laid on top of the fixative.

It is worth noting that fixative generally dampens down color slightly, and some artists who don't like this effect avoid using it. Degas would take into account the dulling effect of fixative and, true to his experimental nature, appeared to enjoy the transformation of his work after fixing. When he added his final emphasis with clear, fresh color, it gave him an opportunity to strengthen particular parts of the image—perhaps the light or color on part of a costume, or the edge of an expressive hand gesture—and then that last layer would remain unfixed.

Degas had his own recipes for fixatives and experimented with different ingredients. Hairspray is a cheap alternative to the products sold in art shops. Some swatches of a single yellow chalk applied in layers to hatched and smudged charcoal are illustrated in the series of images on this page. The charcoal was fixed and the yellow pastel either hatched or smudged and then itself fixed. As the layers accumulate the color gets stronger, either sharply hatched or scribbled color, or soft delicate color. In both cases the layering adds a depth to the surface of the drawing, which if it were a figure, clothing or some other form would make the illusion of three dimensions more believable. In the last image at the bottom of the page, another layer of the yellow has been applied to one half of the swatch and then a lighter yellow to the other half, and one can begin to see how much more depth and variety is possible even with just a slight change in the color.

What is particularly unique and astonishing to examine at close quarters is the variety and energy of mark-making in Degas' pastel paintings. There is an amazing lexicon of scribbles, dashes, dots, hatchings, smudges and squiggles. The swatches below are attempts at emulating some of these graphic gestures. Colors have been layered directly onto the cream-colored paper and also onto a layer of smudged pastel. Because chalk pastels are opaque in nature, it stands to reason that if one wants to give the effect of layers in order to produce depth and complexity in color and form, then there must be a way of seeing through these layers. Smudging with a rag and spreading out the pastel thinly will give some translucency, but with the more solid marks illustrated here, it is the gaps between them that allow the colors of one layer to affect those of the next, in some cases to give an almost three-dimensional feel.

DEGAS & PASTEL
Masterclass: Dancer at Mirror

1–3

In Degas' later pastel paintings the color becomes more vibrant and the marks almost violent—slashing rains of color are built up that disrupt the edges of the subjects. In these images, some of the approaches illustrated in previous examples have been followed, but this time more loosely, and sometimes a little against the definition or establishment of form, saving the clarity for a later stage—if at all.

With each stage fixative is applied and color added over gray and black, smudged and hatched areas.

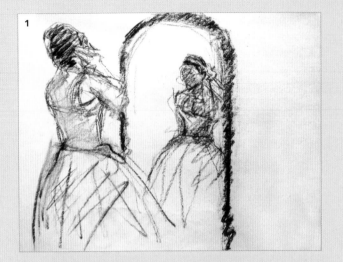

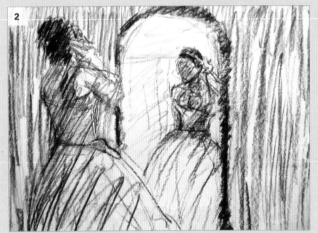

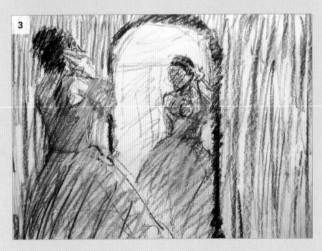

4–5

Color is added to the walls with three different pastels using the side of the chalk, which gives soft, short marks. The colors blend a little as each is applied on top of the last without fixing. However, the overall effect is a bit too colorful, and so at Step 5 more charcoal is laid across these areas to tone down the color.

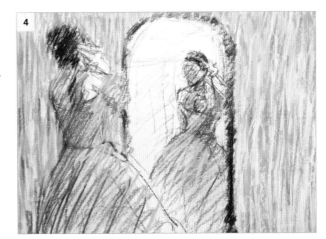

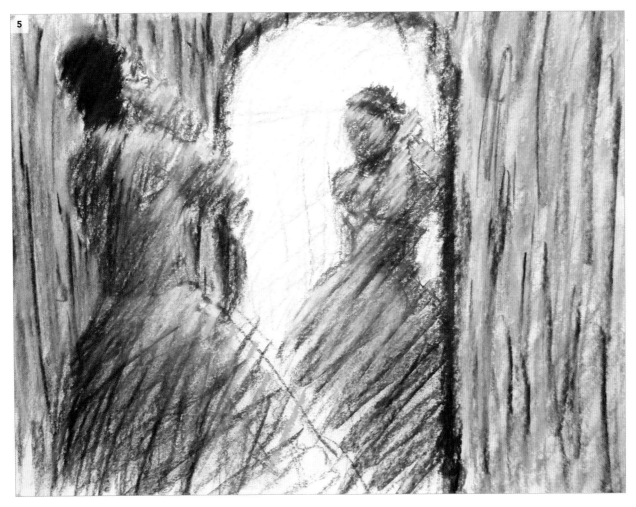

6

Warm skin tones are built up from the darker sanguine to a lighter pale orange and cream combination. The reflective area of the mirror is also filled in with a minty pale green.

7

More layers are built up, including a further coat of charcoal, and the image becomes darker and more atmospheric.

8–9

Once sprayed with fixative the next layer can be easily applied with the side of a yellow stick of pastel—the surface is becoming dense and textured so the pastel almost seems to dissolve onto the drawing. Sickert once described this thick accumulation of pastel layers in Degas' work as being "like a cork bath mat."

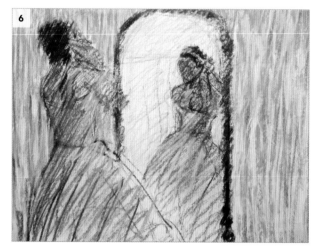

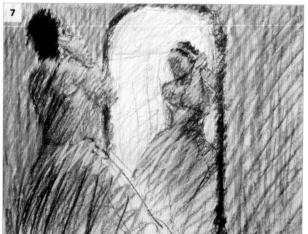

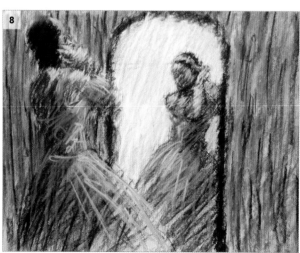

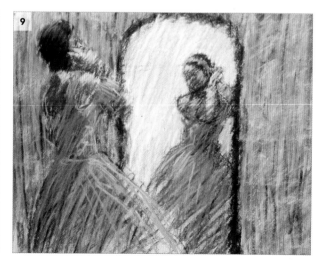

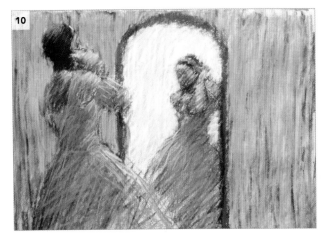

10–11

A final layer of pale yellow is scribbled across the wall in the background and the mood in the drawing lightens. Now there is more movement both in the figure and in the composition as a whole.

The inevitable challenge with all art is knowing when to stop, and it seems likely that buried under the numerous layers, particularly of Degas' later pastel paintings, were many other good places to end the process.

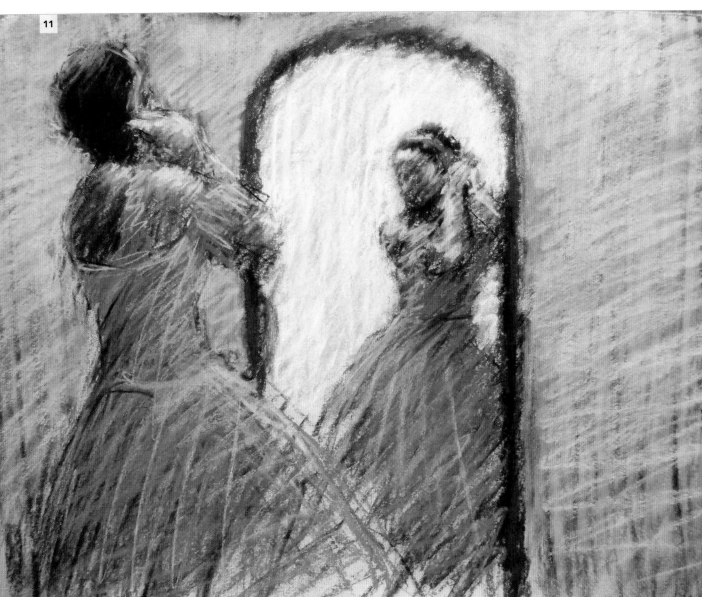

DEGAS & PASTEL
Degas & the Search for Composition

Degas was inventive in so many ways, not least in the area of composition. He seemed always ready to modify the design or arrangement of a picture, often by changing the format—sometimes adding an extra piece to extend it, or cropping the page.

Frequently, a rectangle became a square with the addition of a slip of paper. It can be a useful exercise to start a drawing (with no preconception of how it might eventually be transformed) on a rectangular sheet of paper—as in the image at right, showing an arrangement of three dancers sketched out in willow charcoal on tracing paper. The composition was intended to fill this format as well as possible, with a line of figures receding up toward the top right-hand corner, and a vertical line suggesting the edge of a piece of scenery, or a wall.

An extra slip of paper was then added to the left of the drawing, making the rectangle into a square (below). With this new space suddenly opening up the area behind the scenery, there was the opportunity to add an extra dimension to the picture, and the added figure seemed to suggest itself. It can be difficult to surprise yourself with this sort of exercise when you know where the extra piece is to be added on, so you might want to get someone else to decide, or toss a coin, and so on, in order to make the consequent change in the composition a matter of chance.

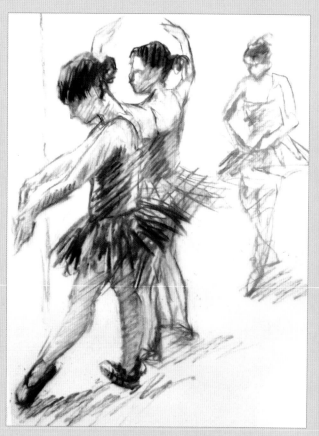

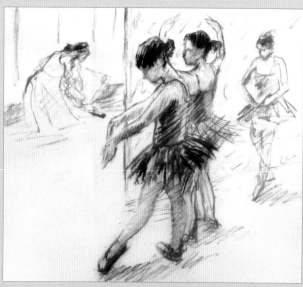

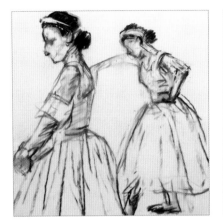
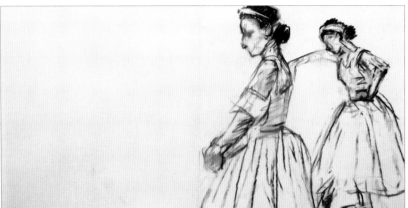
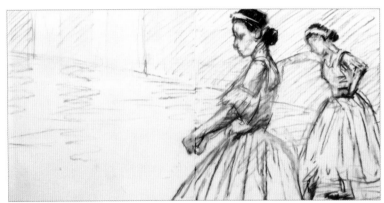

Another approach is to fold a double square piece of paper in half so that the initial drawing is made on a square format.

Once the design has been established—in this example, two dancers fairly evenly balanced, one in front, one behind—the paper can be opened to make the wide, narrow letterbox shape (top right). Suddenly the drawing has a completely different feeling. It seems much more focused on the foreground figure and her imminent movement—perhaps into the empty space.

A little work on bringing her arms forward and indicating the limits of the dance studio demonstrates how far the drawing has been transformed by this newly found composition (above). Many of us would be tempted to fill this empty space with something, but a glance at Degas' work shows numerous

examples of large, empty spaces that add a tension or a dynamism to a composition—the equivalent change in pace to be found in musical compositions; quiet, soft moments contrasted with loud, dynamic passages.

Images can also be composed or re-composed retrospectively. By cropping or reframing an existing drawing, a new and better version can sometimes be found. A useful exercise is to have a window mount available in a different size or format to the original drawing. Using the window, a rectangle can become a square, for example. Laying the window over the picture halfway through the process can lead to a different outcome from the one that was first intended (above right). Following these sorts of exercises a few times can help you become much more imaginative about changing and exploring different possibilities in composition.

DEGAS & PASTEL
Masterclass: The Dance Studio

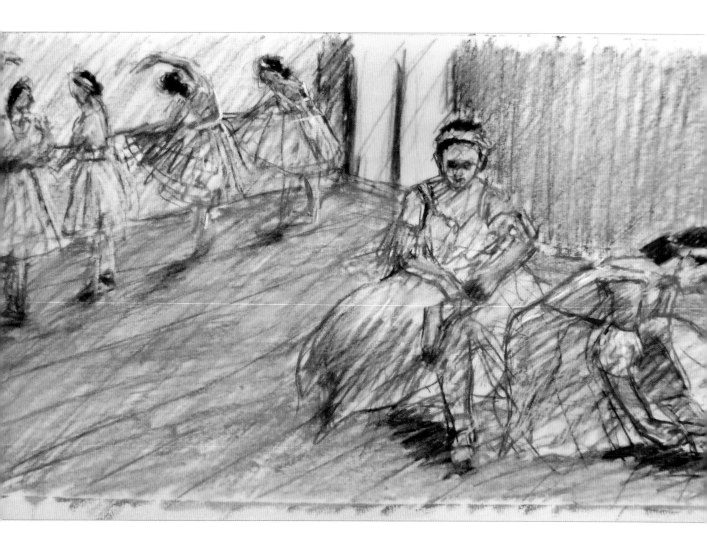

This composition above was generated from several studies of individual dance poses and dancers at rest. Many of the figures are based on the same model posing in a variety of ways. The basic design is influenced by Degas' use of the long format of the double square, which creates the potential for different spaces within the same image. Two larger, resting figures occupy the foreground and a line of four smaller figures is arranged along a bar in the distance. Placing these practicing dancers with their different postures in a line creates a kind of rhythm in the background. Various permutations of dynamic poses drawn together seem to generate their own believable sense of activity.

1

Tracing paper is laid over cream-colored paper, roughly double square in format, and the figures are sketched in from other drawings, using plenty of fine lines.

2

The charcoal layer is fixed and color applied to the background with chalk pastel mixtures of a yellow-brown and an ochre. The marks I use here are a kind of vertical hatching, which helps suggest the direction and solidity of the wall behind the dancers.

3

More pastel is laid in to the walls and floor (horizontal marks here suggest the plane of the floor and even the floorboards that it is made of). These marks are applied loosely and allowed to overlap with the figures, so that the lines of the dancers are lost in places. Ultimately some of these edges will be found again and redefined, but they will be selected to give a particular emphasis to the finished work. Degas said, "Don't draw what you see, but what you wish others to see." This final emphasis of found edges was how he showed others what he wanted them to see.

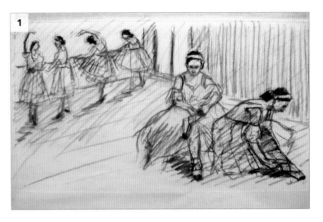

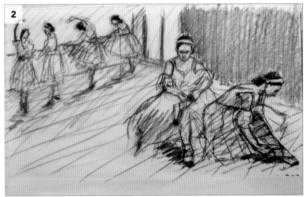

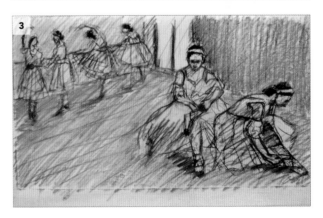

4

A first layer of color is now added to the figures. Notice there are only a few, closely related colors: yellows, browns, grays and orange skin tones. One of Degas' strengths as a colorist was his use of a limited palette—both bright and muted colors, but not too many of them at once.

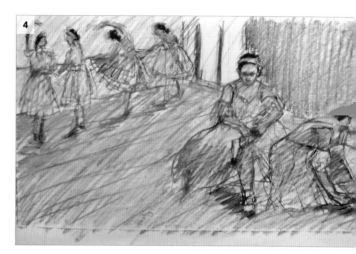

5

A second layer of pastel is added to the figures.

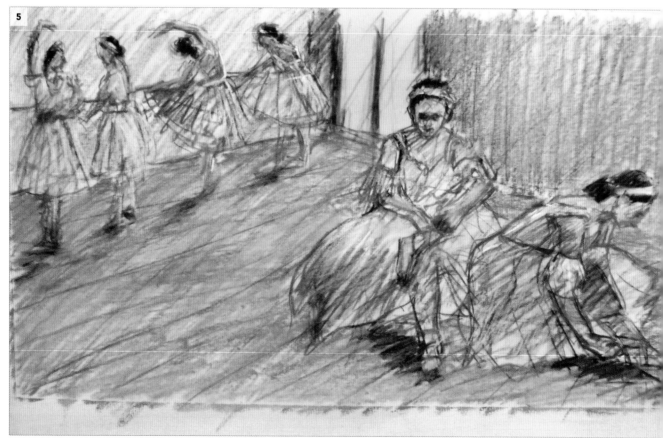

6

Notice that the background figures are left more loosely drawn and are less detailed. Some even merge with their surroundings a little. This all helps them to recede into the distance.

7

Smudging the colors on the floor and adding more pastel makes it more solid, but also a bit quieter, so that it isn't too distracting from the main interest in the drawing. More chalk is also layered onto the foreground figures, which will help to bring them forward.

8

Areas are smudged, sprayed with fixative, and the same colors re-applied over the top to enrich color and depth. The greater amount of detail and observation in these foreground figures will make them more interesting and help them to stand out.

9

The process can be continued with a restating of shadows and dark marks with charcoal, and perhaps some color over it for a last emphasis.

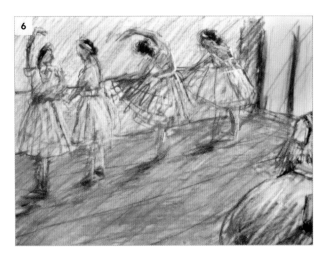

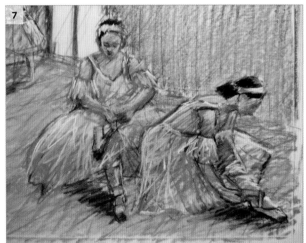

DEGAS & PASTEL
Use of Tracing Paper

Degas loved to use and re-use particular poses in different combinations, and return to certain color schemes in various images. He also liked to view the same pose from a variety of angles (his wax figurine sculptures aided in this—they could be turned and viewed from above and below to help select the best viewpoints). In the same way Degas would employ tracing paper. He already liked it as a fluid surface for charcoal and pastel, but would also investigate the reversal of a particular pose by turning the tracing paper around—sometimes you find that a pose is more dynamic in one direction than in the opposite.

Try the wonderfully surprising experience illustrated below: A fairly dynamic pose is drawn in charcoal lines and shading, smudged, and re-hatched. When the tracing paper is turned over a softer, reversed version is revealed.

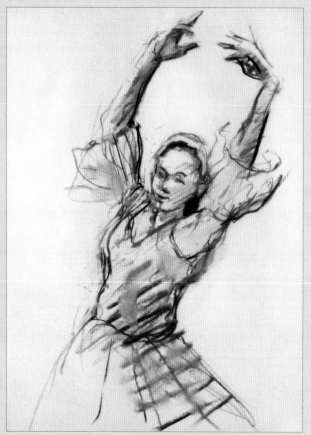 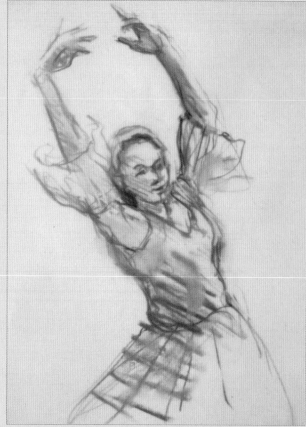

In the reversed image the movement in the pose, and therefore also in the composition or design as a whole, seems to travel more easily from left to right, and this may be the more dynamic of the two versions. Sometimes Degas would combine both versions of a pose to create a repeating pattern of figures engaged in a similar movement, but seen from differing perspectives. The dancer whose pose had been reversed in the second image was carefully transferred onto a new piece of tracing paper by laying it face down and rubbing the back of the drawing. Only a faint version of the figure was transferred, as you can see in the image on the left (below), but this was enough to be developed into a stronger drawing and combined with the original version of the pose, which was made into a larger figure in the foreground, traveling in the opposite direction.

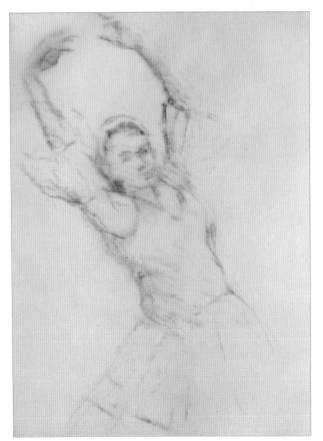

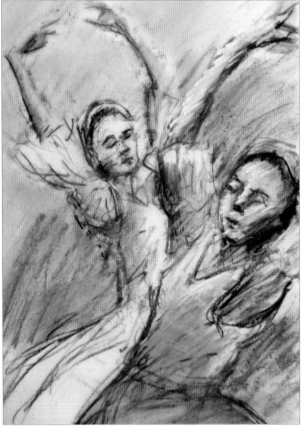

DEGAS & PASTEL
Exercises

The following exercises are intended to help you put into practice some of the ideas illustrated in this chapter on Degas' innovative use of the pastel medium, his mastery of movement and his imaginative approach to composition.

1 LINE ONLY

Start a figure drawing either on tracing paper or tinted cartridge paper and restrict yourself to drawing in line only. It is worth attempting the discipline of keeping the charcoal on the page using a continuous, flowing line that takes you from one part of the figure to another—connecting your fluid subject. The human figure—its anatomy of interconnected muscle and skeleton—is a highly fluid phenomenon, and so can be well represented by a flowing line. Make sure that you don't dwell on any particular part of the drawing or of the figure at the start; keep the line moving, and initially keep it delicate and faint until you are happy with your judgement of form and proportion (as happy as Degas might have been at this stage, at least). With experience, you will gradually recognize that some lines are more important than others. The outline of the woman's shoulder in the image on the right, for example, is necessary to bring that part of the figure forward, in front of her head; the hint of a line running down parts of her spine is important to suggest the half of her back that is out of sight—by indicating the far side of the back the body will be more three-dimensional, or less flat. As you begin to instinctively identify the significant lines you will get to them quicker and start producing stronger and more economical drawings. This sort of exercise is worth doing quickly—time yourself and allow no more than five minutes.

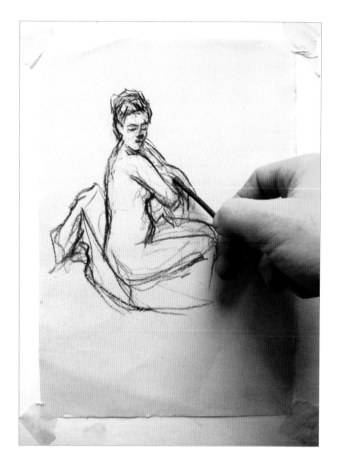

2 TONE ONLY

Choose a pose and viewpoint with lots of tonal contrast. You could, for example, position your model against a window or a light wall, or employ the use of strong, directional artificial lighting. It can also help to have contrast within your setup: the model might have dark hair and pale skin; you could cover a chair with a light drape and give the model a dark towel—all things that will make it easier for you to see tonal contrast and allow you to use one shape to define another.

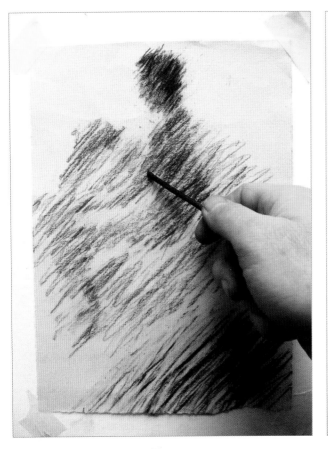

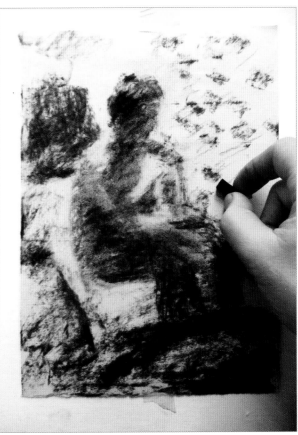

Now, with willow charcoal, make a tone-only drawing. This can be done using a diagonal hatched or scribbled mark, using the side of a thick piece of willow charcoal. Sometimes the thick sticks have a bit of a skin that you need to get off by rubbing them onto a rough surface. Look with your eyes half closed and identify the main light and dark shapes. Open your eyes and begin to refine them, using the eraser to subtract and the charcoal to add, as shown above.

3 SMUDGING

After a line and tonal start to a figure drawing (right), smudge the image with your fingers (below left). Do this selectively—don't obliterate the whole thing—but at the same time don't be too timid. Aim to make a difference to the drawing and introduce a bit of chance or accident.

Try modeling anatomy with short hatched marks, changing direction to indicate the planes on the surface of the figure. Then heighten the contrast with short hatched marks of light in white chalk (below right).

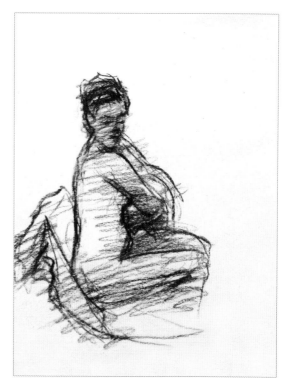

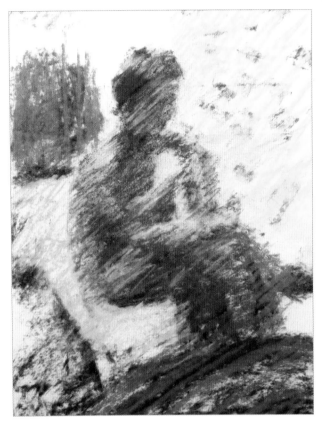 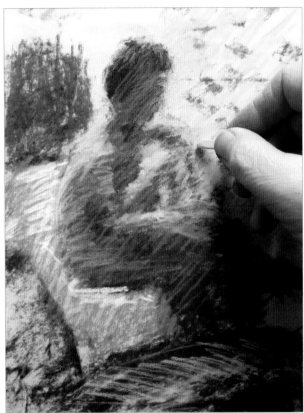

4 THE WRONG COLOR

Choose examples of drawing from the previous exercises that you are least happy with and, having fixed them, select a number of wrong colors from your pastel set. Be instinctive: look at a number of colors together in your hand or laid onto some white paper—what do you like the look of; which go together well?

Don't try to predict the outcome of the exercise, but do choose a range of bright or colorful pastels, together with some neutral or muted colors, and some light and dark contrast. Apply these loosely so that some of the edges you created in charcoal begin to be lost (above left).

Fix this layer, then layer on the right colors, for example more naturalistic colors, if you prefer—or just whichever colors you wish to finish with (above right). If you make sure that the layers are see-through, either by hatching or using a broken wash with the side of the pastel, then the effect of the wrong colors showing through combined with the final color scheme can be spectacular—there will be depth and a degree of surprise to the drawing.

DEGAS & PASTEL
Exercises

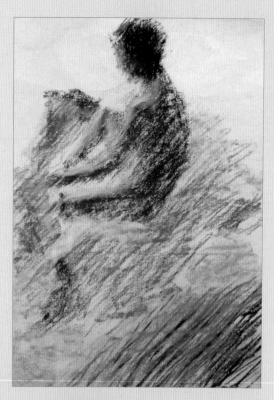

5 SOFT & SHARP LAYERS

Onto a fixed charcoal beginning alternate soft layers of color (applied with the side of the pastel stick) with sharp layers (applied with the tip of the pastel), as in this example (right).

As layers build up, confine the pastel just to certain areas that you wish to be more intense or complex (below left). The tip of the pastel will allow you to define in a precise way, while the side will tend to blur and soften edges (below right).

By standing back from your work you will be able to decide where definition is best placed, and where areas should remain out of focus or more atmospheric.

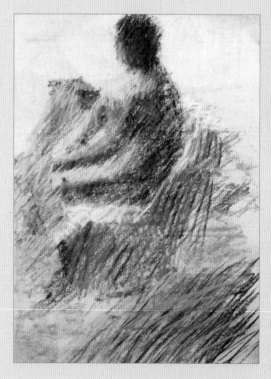

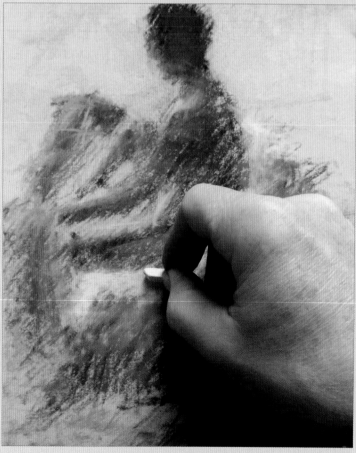

6 COLOR SWATCHES

Choose some fabrics or patterned surfaces and build up some layers of pastel and charcoal that represent the colors and textures you see (above left).

Try this with other subjects like hair, or the skin on the back of your hand (right and above right).

Without having to worry about accurately representing form or shape, you can begin to extend the ways in which you work with layers of pastel. As a result, your instinctive use of the medium when you are in front of a whole subject, such as a draped figure, will be all the more inventive.

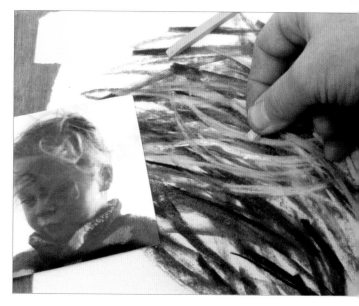

7 EXTENDING & CROPPING THE COMPOSITION

Reread the section on composition on pages 56–57 and try some of the deceptions described there. Start a drawing in earnest on a rectangular piece of paper and then ask someone else to decide where you should add a strip of paper to turn it into a square (don't show them the image though—this exercise works best when left to chance), or toss a coin or throw dice to decide. Then resolve the picture with the new, extended composition.

Try other variations such as adding a square to a square, and find ways of developing a double square image without necessarily filling it with lots of activity. Also try cropping your drawings with window mounts or a strip removed by random selection.

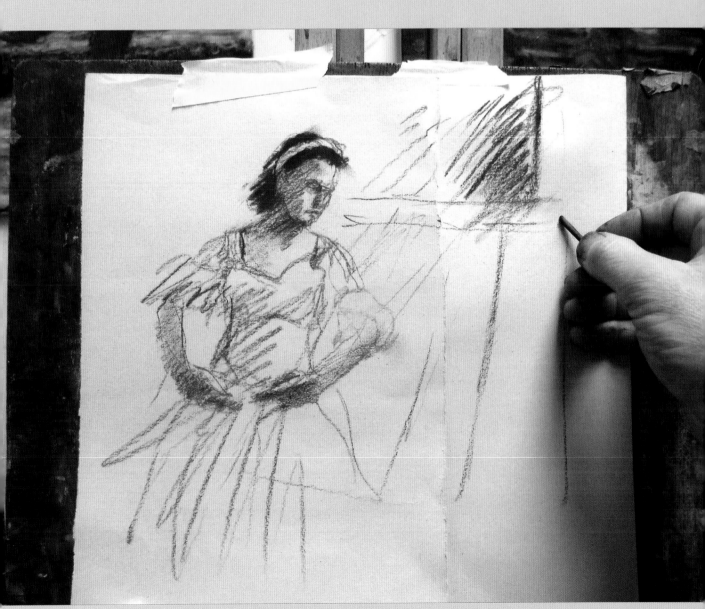

8 TRACING PAPER TRANSFORMATION

Choose a pose that you are convinced has the best orientation as it is, where you can see the movement in a particular direction. Draw it onto tracing paper—as a line only, or a line and tone drawing. Then reverse it by turning the paper over. It is often the ones you're least expecting that work the best when reversed.

It is also good to try this technique on drawings that you consider to be unsuccessful. Sometimes the problem can turn out to be not the drawing of the figure, its anatomy or proportions, but the way the whole form works within the composition—and by reversing its direction the particular figure can finally make sense.

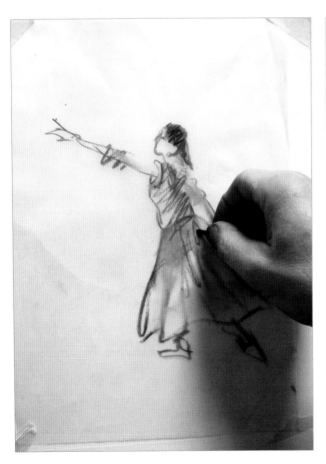
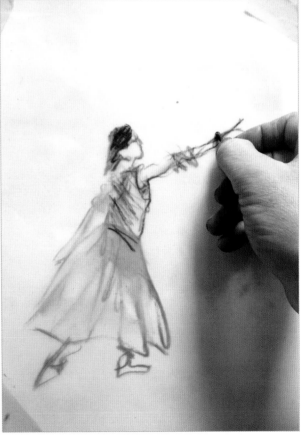

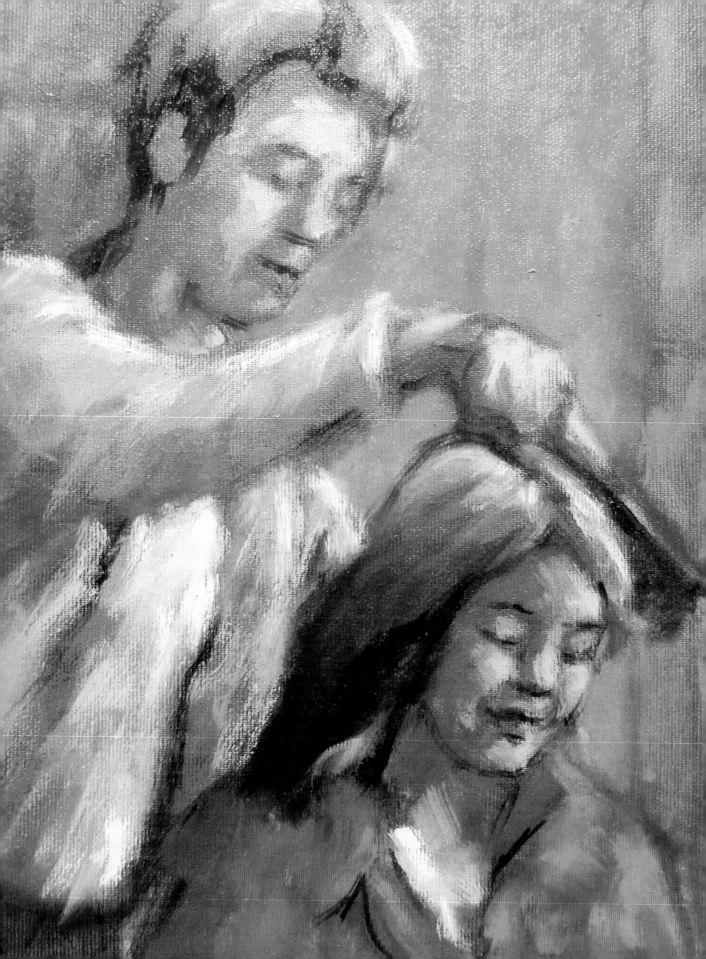

CHAPTER 4 : DEGAS & OIL

Degas admired the traditional approach to handling oil paint—a process of building up layers in a particular sequence: from the monochrome *ébauche*, through blocks of color, to final layers of discrete painted marks that resolved the whole image. He studied the Old Masters in the Louvre and spent time in Italy where he examined the work of the Venetians, particularly Titian and Tintoretto, in person.

Art training in the mid-nineteenth century was undergoing a revolution, and artists increasingly sought out the studio or atelier training of more established and experienced masters. Degas studied with Charles Gleyre, along with the Impressionist founders Renoir and Monet. This, in essence, is the picture of Degas the artist—a wonderful synthesis of the thoroughness and rigor of the classical approach together with the innovation and individuality of the modern approach. Constitutionally Degas was a draftsman, and this influenced his approaches to paint. He preferred thinner, more fluid paint, and a smooth surface that would take a flowing line. His early work was scraped down "as smooth as a door"—with a fluid line starting and often finishing the work.

Increasingly Degas concentrated on pastel, although he continued to paint and many of his series of the pastel phase can be found repeated in oil. His later oil paintings are clearly influenced by the pastel approach—built up in loose and very textured layers, with paint applied with fingers and other implements—and then defined at a later stage with incisive lines and emphatic marks; the resulting work becoming more abstract and colorful.

This chapter explores some of Degas' key approaches to oil paint. You will find advice on how to prepare and work with the modified oil paint, *peinture à l'essence*; and its connection with pastel technique is explained. We will unpick his "series of operations"—the layering of oil paint from a monochrome start, through scraped down layers of color, to a resolution with the adding of a final emphasis. Masterclasses will cover brush technique and also the looser and more textured ways in which Degas' later work in oils developed. Finally, a series of exercises are suggested that will provide some experience of the types of stages and decisions that Degas might have taken as he evolved particular oil paintings.

DEGAS & OIL
Peinture à L'Essence

Degas' desire to draw with paint in a fluid way was satisfied in part by adapting an older technique of modifying the oil content of the paint and applying it to a smooth, absorbent surface. He hated working with thick, oily paint, and as part of his investigations into speeding up the painting process he experimented with *peinture à l'essence*—an approach that began with leaching some of the oil out of the paint by laying it onto blotting paper. The resulting product is less oily and —since it is the oil content that is responsible for the slow drying of the paint—if this is then diluted with a volatile solvent, such as turps, and painted onto an absorbent surface, the drying process is hastened and the artist is able to build up layers far more rapidly. This medium was often applied with a small brush in a linear way, with the colored ground of the paper surface showing through in various places and

unifying the image—not unlike the pastel technique that he would go on to develop. Toulouse-Lautrec admired Degas' work and shared his graphic approach. Lautrec also took up the *l'essence* medium, and the hatched and scribbled paintings he produced resembled pastel works.

This is a technique worth investigating—it can be particularly useful for rapid sketching in oils. First the paint needs to be laid out on a sheet of blotting paper.

If left overnight the oil gradually leaches out onto the paper and the remaining product is much thicker and stickier than what was originally squeezed from the tube. It can then be carefully scraped off the blotting paper and transferred to a palette.

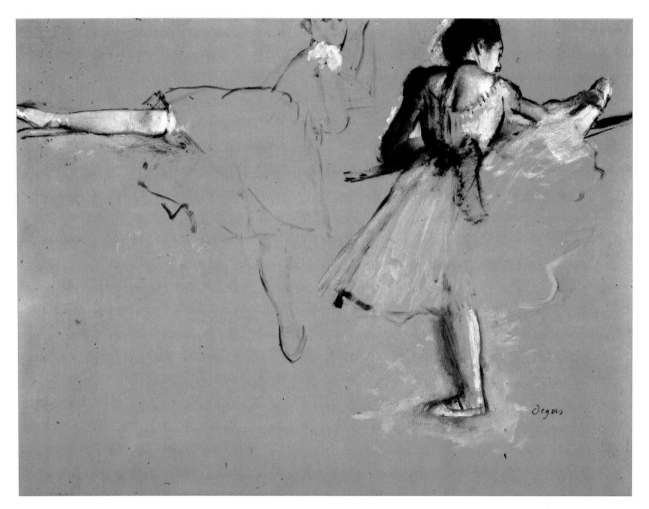

The medium, diluted with turps, behaves not unlike gouache when that paint is combined with water—it can be used thinly and transparently, or more solidly to create opaque effects. Also, like gouache, apparently dried out lumps of l'essence can be revived with a drop of turps and set to work again (I found I could leave this medium for about a week before a skin began to form).

Paper or card should then be primed with size or rabbit-skin glue. The card needs to be sealed so that the paint can flow across and not spread into the surface of the sheet. Using size means that the color of the card is retained.

PEINTURE À L'ESSENCE

Study for Two Dancers at the Bar, Edgar Degas,
c. 1868–1870

This study of dancers in the *l'essence* medium beautifully illustrates Degas' ability to draw with this modified oil paint. The dancer on the left appears to demonstrate an intitial stage in the artist's process—a rapid sketching of some of the outlines of the figure with a semi-transparent black line. The next stages are seen in the other dancer. Shadows and hair have been blocked in with more black, then the white has been laid on top in varying densities to denote light on the figure and the costume. The green color of the card unifies the image and brings out warmth in the black and white paint, with some of the whites taking on a pinkish tint.

DEGAS & OIL
Peinture à L'Essence

When Degas made his studies of dancers in *l'essence*, he chose colorful pieces of paper and card, and painted in black and white, with the paper showing through in different places and mixing with the color of the surface.

In the image top right, complementary opposite colors alizarin crimson and viridian from the prepared *l'essence* paint are mixed together, and the resulting black diluted with turps. A line drawing of the dancer is made using a very fine sable brush. The line varies naturally with the amount of paint, and whether it is fluid or dry, and the figure has a good three-dimensional quality helped by the mid-tone of the background color. The particular pigments mixed here are also transparent, so there is a transparency to the line itself. The reduced oil content and the absorbent paper surface help the paint to dry and, left by the heater, this was ready for the next stage in about five minutes.

In the second image (right, center), a pattern of shadow is laid onto the head, arms, legs and a little to the dress. Because the original line is dry it retains its clarity and can be painted across with the tone. After another period of drying a third layer of white paint is added (below right), which heightens the contrast in the image. Each layer of paint has been diluted, and very small quantities used—it should be stressed that "very small" really does mean very small, so apply carefully.

There is plenty of transparency to the last image (below right), in particular the black and gray lines and shadows showing through the white layer and adding color to the thinner whites, making them appear pink. So with this very limited color scheme—just green paper, and black and white paint—a range of subtle color contrasts is generated through complementary effects. This is a valuable exercise to experience the connection between color and value, as well as transparency. All these factors came into force in Degas' early approach to oils—all building on his traditional training.

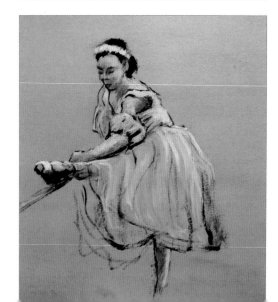

Try this approach on different colored papers to see the effect of the background on the black and white mix. In the image below, a bright red sheet of paper has been used, and in order for the figure to stand out from the warm red it is necessary to add orange to the white to make a warm skin tint that will contrast well with the pure white of the dancer's dress.

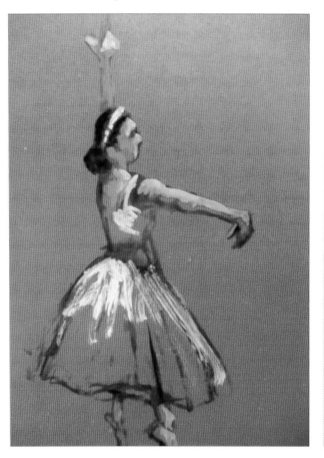

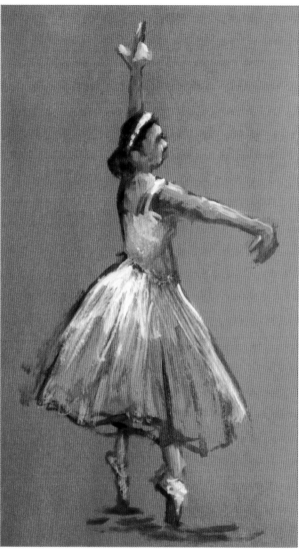

After drying for ten minutes, a final layer of lighter color is added to the head, arms and dress (above right). Because each layer is a little absorbed by the card, a new application of exactly the same color will stand out more strongly than the last. Where necessary, this can be dabbed with a rag to soften or reduce its effect. Conversely, it can be applied a little thicker and more opaquely in order to really stand out. Thus, a little like chalk pastels, *peinture à l'essence* allows for great variation in its subtlety and nuance by applying the same color in layers and in differing densities.

DEGAS & OIL
Masterclass: Study of a Dancer

Degas sometimes used the *l'essence* technique to make portrait studies for commissions. This Masterclass of a portrait study of a dancer's head emulates this particular approach.

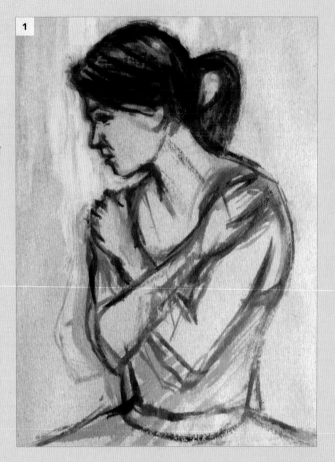

1

The dancer's head and upper body are sketched out with the black mix from alizarin and viridian. When dry, the numerous outlines are given definition by painting in some pink background color. The dress is sketched in with a turquoise, and the hair is also blocked in. As with pastel layering, the repeated searching outlines seem to add some depth and movement rather than detract as mistakes.

2

A mid-tone skin color is added using a broken, hatched mark—this allows the gray of the card to show through and continue to unify the image, as well as providing one of the constituent colors for the skin, namely gray. Then lighter skin tones and highlights in the hair are placed on top—this time into the still-wet paint, so that there is blending on the painting and a softer transition from one color to the next.

This demonstrates the versatility of the l'essence technique. Oil paint can be layered quickly as the layers dry, but there is also still enough time for wet-on-wet mixing within each layer.

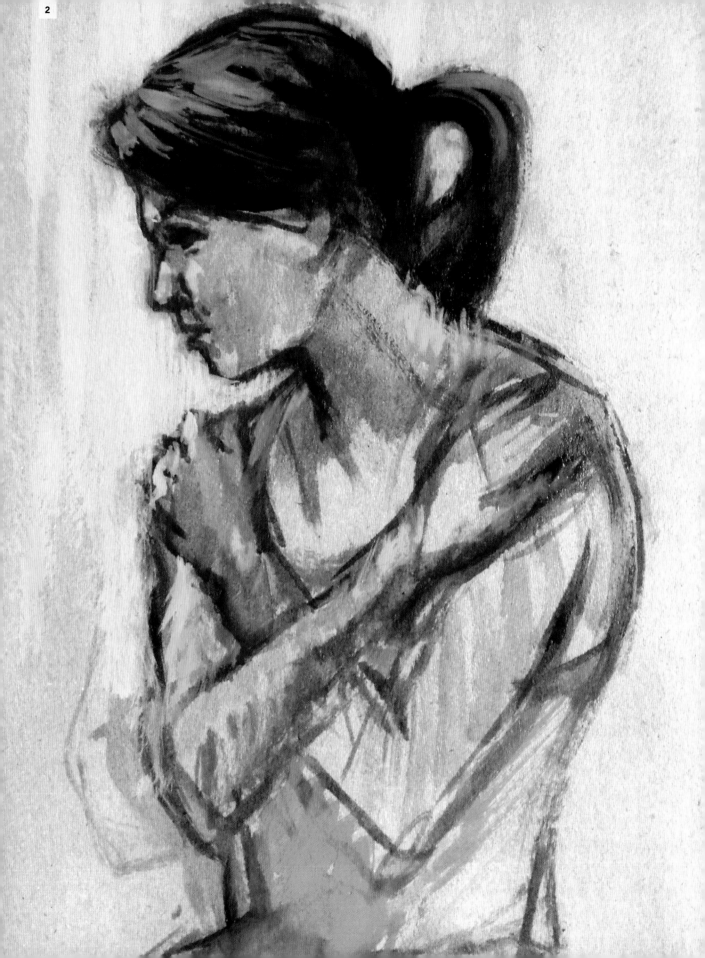

DEGAS & OIL
Scraping Down

Degas disliked a thick buildup of oily paint—in his early work he preferred layers of thinned paint drawn onto a smooth surface in a fluid way. His boast that his paintings were as "smooth like a door" reflects this handling of the medium. Scraping down the surface of the wet paint is a method for smudging and softening the painting—it also helps reduce the buildup of the oil. Scraping down softens the image, bringing together differences in color and tone. It also leaves a smoother surface to the canvas, across which dry paint can flow more easily or, if you wished to continue with the wet painting, more wet paint can be floated on the surface of the fibers of the canvas. If subsequent layers of paint are broken or translucent then colors that have been pushed into the weave will be visible in places and can contribute to the overall color scheme.

It is also possible to scrape down a dry painting. This requires a more vigorous scraping and effectively removes the top layer. There is not much softening of the image—more a subtracting of the paint content. The weave of the canvas is visible in places and the painting is ready for another layer of color and emphasis. Thin oils painted over this scraped surface, particularly if they have some transparency, will add depth and weight to the painting without too much paint being applied.

Scraping down can be done a few times during the painting process, but is most effective near the beginning, when paint and color can accumulate in the weave of the canvas. It can also be usefully employed as a technique toward the end of the painting, prior to the final emphasis being placed. By scraping down and softening the image, the last emphatic contrasts of light and dark, or brighter accents can be restated to conclude the process. This can equally be used when dealing with details such as features—eyes, for example, can be clearly defined, scraped down and then delicately restated in a slightly more subtle way as a final conclusion to a face.

SCRAPING DOWN
Mademoiselle Malo, Edgar Degas, 1877

It is clear that the woman's head in this painting (right) has been scraped down, as the raised fibers of the canvas are visible on the side of her cheek and the side of her nose. The front of the nose and the center of the lips have had thicker paint applied to them that stands out from the weave of the canvas. This restating and emphasis has also been used in the center of the eyes, so that they stand out strongly, while a fainter effect is achieved on either side of the pupil and iris, where the threads of the canvas can be seen as the paint is thinner and scraped down.

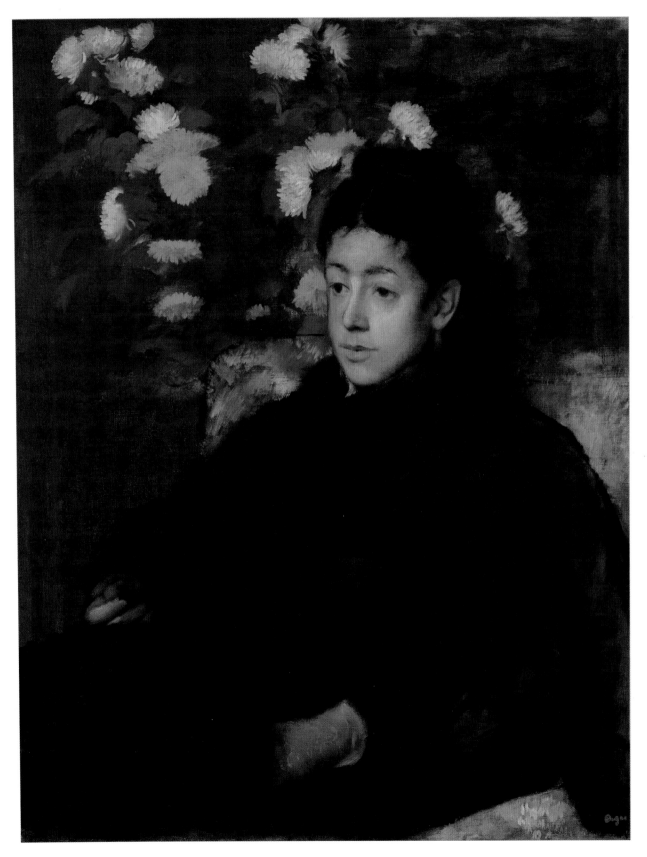

DEGAS & OIL
Masterclass: Study of a Girl's Head

This painting was approached in a manner similar to Degas' early oil technique. That is, painting layers of thinned oil paint, scraping down along the way.

1

The painting begins with a sketch of the girl's head in a diluted brown, made from alizarin crimson, ultramarine and lemon yellow, thinned with turps and linseed oil. The canvas has been primed and a beige ground prepared using acrylic paint. The sketching out is done in a fluid line, which can be smudged and redrawn until the appropriate contours are created. Areas of tone are also added to the hair and shadows on the face. This is left to dry.

2

The wet painting is scraped down by laying a palette knife on the surface and scraping the paint into the weave of the canvas. It may be necessary to do this several times in order to cover the whole image, and remember to wipe the palette knife each time so that the colors in each area are kept fairly clean. The result is a softened image and a smoother canvas.

3

Background colors are introduced to the painting and some more color added to the clothes. The features are strengthened with a cool, dark gray-green. If these marks seem overdone, it may help to scrape them down. An eyebrow, for example, will then be a little absorbed into its surroundings and will therefore be more subtle and less flat.

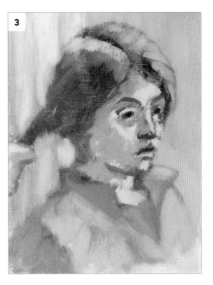

4

Both middle and lighter, warm skin tones are applied to the forehead, the upper eyelids, the front of the nose and chin. These are painted with a small brush and with fluid paint allowing the colors to blend a little on the painting's surface. A red is applied to the mouth and a dark line is added to divide the lips. A lighter (grayer) red is also laid into the bottom lip to indicate the light falling here.

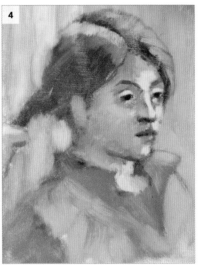

5

The dry painting is scraped down, or rather the raised dry paint standing out from the picture surface is scraped off until the surface is relatively smooth. Some contrasts will be reduced and areas thinned to the point that the bare weave of the canvas can be seen in places—but the effect of scraping dry paint is much less dramatic than when wet. Degas liked to keep the surface flat and smooth, and also to avoid the buildup of too much oil—he liked a lean painting.

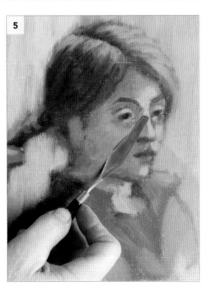

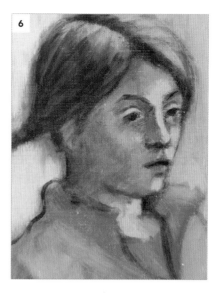

6

Thinned black (alizarin and viridian mixed with turps and linseed oil) is drawn across specific landmarks on the girl's head using a thin sable brush. The hair is darkened, along with the eyebrows, eyelashes and the line of the mouth. An edge is drawn in other places, including the far side of the cheek, the jaw, around the collars, and, particularly strongly, the shoulder and back. Because this thin mixture is transparent it appears differently in places depending on what is underneath. So a vibrant line is created and one which can be softened with a rag where necessary or restated more strongly, as required. Some cool shadows are enhanced on the face with very small quantities of this black, and again softened when needed— much like a glaze.

7

The next stage is to apply warm skin colors, particularly to the lighter areas, again with a small sable brush. The different colors and values can both be blended on the painting, or carefully placed side-by-side to maintain their contrasts.

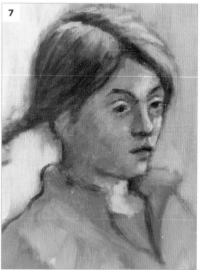

8

Here color is being applied to the clothing. Thicker, drier paint is applied with a dry hog hair brush, held almost parallel with the painting surface so that it drops onto the textured and woven canvas, and leaves a textured and broken mark. The same is done to the triangle of green t-shirt.

9

Finally, light edges are drawn on with the sable brush and thinned pink paint.

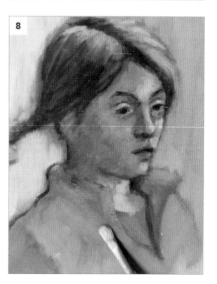

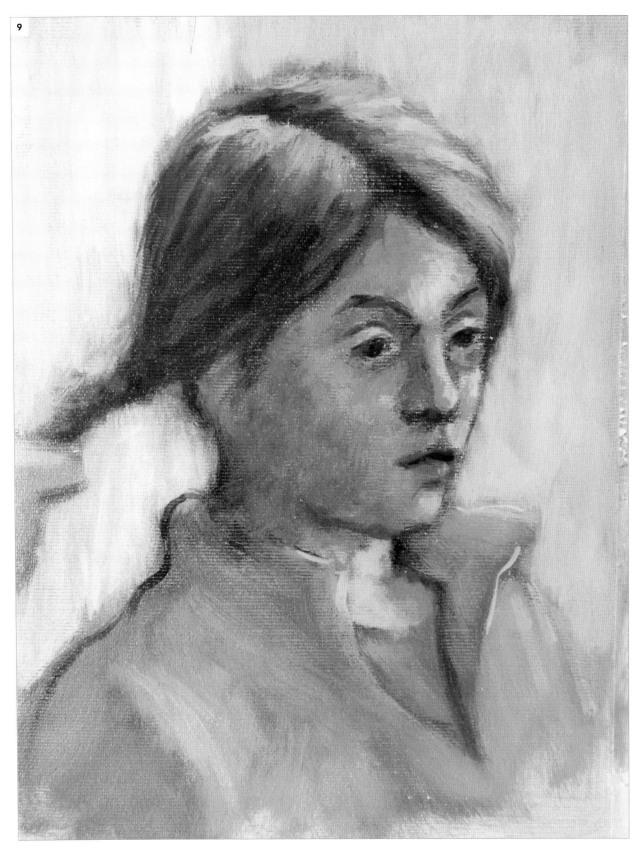

DEGAS & OIL
Brush Technique

Brush technique refers to both the handling of oil paint and its consistency, which tend to be related. Thinned paint can be used in a fluid way, often with soft sable brushes that soak up the diluted medium. Thicker or drier oil paint is best picked up on the tip of a stiff hog hair brush and either dragged across a dry, textured surface to create a dry brush effect, or floated by rapidly dropping it onto a surface of existing wet paint while trying to minimize the mixing of the two colors. This latter *alla prima*, or wet-on-wet, oil painting can be controlled so that some colors float, barely mixing with those beneath them, and others are worked in so that new mixtures are created on the painting's surface. Like the lexicon of pastel marks, this combination of brush and paint consistency offers a huge range of possibilities—hatching, scumbling, stippling and long flowing lines. When his brushes seemed inadequate to the task of subtle placing of color marks, Degas, like Titian before him, resorted to using his fingertips.

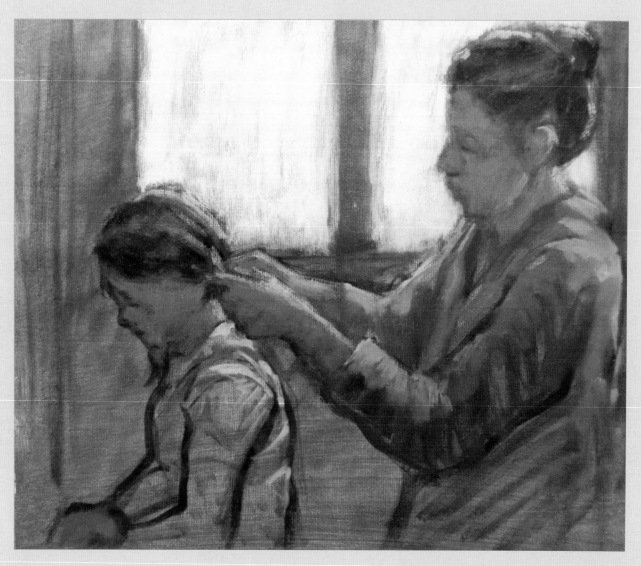

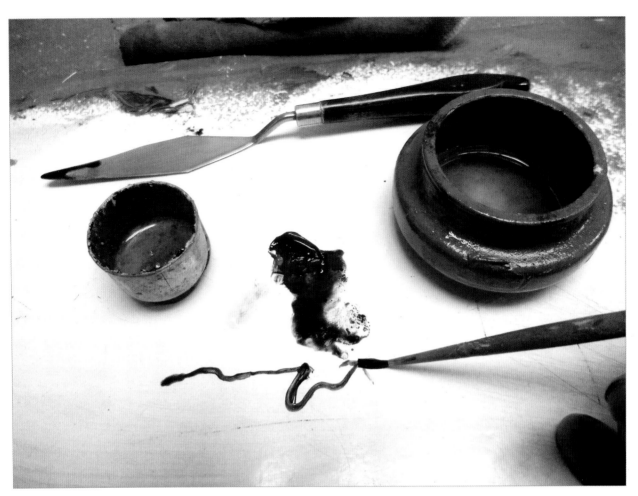

In the image above, a brown mixture has been made from alizarin, lemon and ultramarine, and diluted with some turps and linseed oil (approximately two parts to one). This thinned paint can be applied in a fluid and even linear way with a thin sable brush.

The job of the traditional stiff hog hair oil-painting brush (right) is to pick up a quantity of paint on its tip and deposit it directly onto the surface of the painting. This allows for more descriptive and even expressive brush marks—what Degas called "drawing with paint." If the brush is held parallel to the painting the mark will be fresher and the paint less likely to be worked into whatever wet paint may already be there. If the surface is dry, a broken dry brush mark will be created.

DEGAS & OIL
Masterclass: Woman Plaiting Girl's Hair

Degas' draftsmanlike early oils were smooth and finished—a process characterized by the fluid line that started the painting, corrected along the way through scraped-down layers, and concluded with calligraphic emphasis. This Masterclass will attempt to emulate Degas' approach, which in turn drew much from the methods of the Venetian painters of the past. The painting was started on a mid-tone ground of a warm brown (the canvas was primed with gesso, and then a layer of acrylic—burnt sienna and white—was painted on for speed). It is helpful to begin on a mid-tone surface as the lighter and darker marks stand out from it, and areas not covered with paint will allow the ground color to unify the image. The figures of the woman and girl were sketched out in a thinned brown oil mix of ultramarine, alizarin crimson and lemon yellow. These were diluted with turps and linseed oil, so that a fluid line drawing was produced. This ink could be smudged and rubbed out where necessary, so the process of establishing the composition was gradual and easy to change along the way. In true Venetian style the painting would then be built up in layers keeping to the basic design, but incorporating ways in which edges in particular could be altered, restated, lost and found. Once the sketched stage was dry (after a day or so) a first layer of color was applied to the skin and hair.

1

The composition of a woman plaiting a girl's hair is sketched out in a thinned brown oil color, diluted with turps and linseed oil. The canvas has been prepared with light brown ground, and the flowing lines create a sense of three-dimensional form in the figures. A window and an interior are suggested with a few lines. Since the paint is diluted and therefore quite fluid, either a soft sable brush or a stiff hog hair brush can be used at this stage. The sable gives a lovely calligraphic, lively line, but isn't able to carry much pigment, so strengthening the line isn't easy. The hog hair brush will carry more of the drier paint and allow a darkening of the line where desired.

2

A pale gray-green shadow color is mixed on the palette and applied loosely with a stiff hog hair brush (No. 6). It is good to do this in a loose, hatched way, so that there are gaps between the brushstrokes where other colors could be introduced and so that the (now dry) outlines can be broken up and at times lost beneath the layer of color.

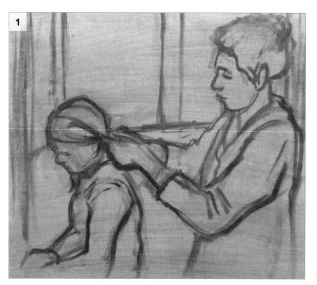

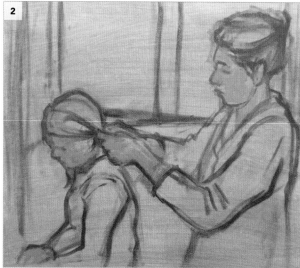

3

A cool shadow color is added to the face, modeling its form
with dark and darker planes. Where the two tones overlap,
the wet paint will mix and blend a little. It is good to apply
the paint with the brush almost parallel to the painting so
that the paint can either be dropped onto the canvas and
floated on the surface, or be pressed in a little to encourage
mixing. Very subtle variations in this handling of the brush
loaded with wet paint will allow you to make either strong,
emphatic contrasts, or soft, delicate effects.

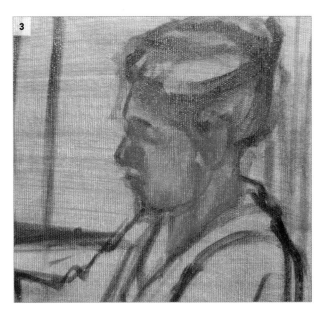

4

The hair of both figures is blocked in with lighter and darker
yellow-browns. This time the brush marks are longer, flowing
lines—appropriate to the texture of hair. A combination of
blended areas and more sharply defined contrasts are attempted.
A thin wash of a cool off-white is dragged across the window
areas. Care is taken to allow the warm brown of the original
ground to show through, so that the translucency of the glass
is suggested using scumbled paint, rather than a thicker,
opaque effect.

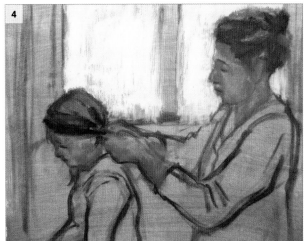

5

This detail shows how the thin white paint used in the
window helps to define the contours of the woman's head.

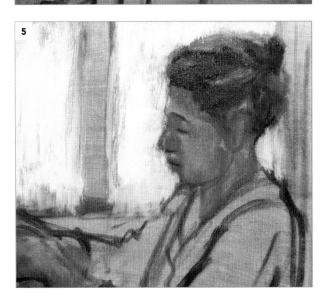

6

Warm skin tones are added to the faces and hands. A mid-tone muted orange is laid across the shadow colors and blended a little on the painting. However, a greater amount of the lighter highlight color is dragged along the tops of the woman's hands using a dry brush, so that it stands out on the surface of the painting, giving emphasis to this light effect.

7

A highlight is added to the hair in a similar way. If the brush is heavily loaded with fairly dry paint, the weave of the canvas will catch it and produce a broken, textured mark, not unlike that of a pastel on paper.

8

Clothing is blocked in with contours around the woman's top and a start made on the pattern of the girl's cardigan.

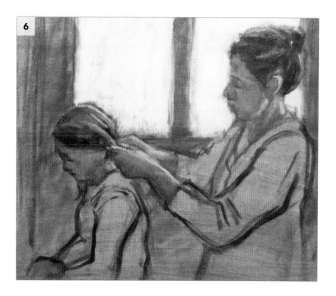

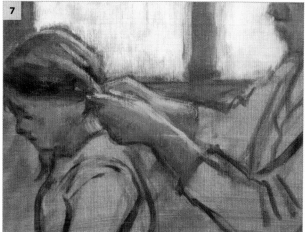

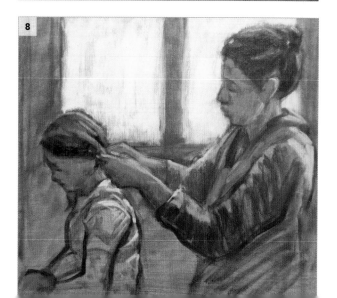

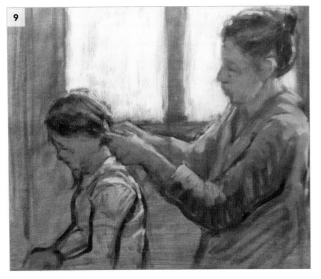

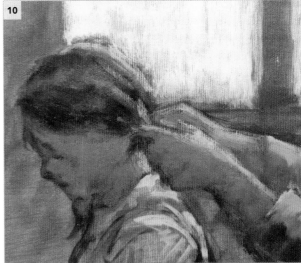

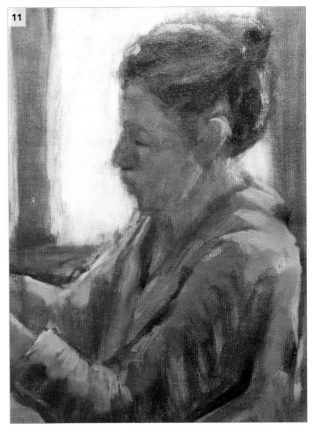

9

The painting has been left to dry for a couple of days, and work now continues on the heads and hands of the figures. A warmer orange mid-tone is scribbled across the middle of the woman's hand and the faces. In this way it brings together some of the colors underneath, allowing them to show through in places. Then the lighter skin tone is repainted on the hands and the backs of the necks. The hair is also treated in a similar way with yellow-browns.

10

The detail shows just how textured and broken these highlighted edges to the hair and hands are. As broken lines, they integrate better with the colors around them and also stand out in a more vibrant way. This requires bold, confident brushwork— have the right color mixed on the palette in sufficient quantities to allow a loaded brush to be handled in this very direct way.

11

Sometimes just small touches of color are needed to be added to an area of the painting in a lively but controlled way. Here, not a brush but a fingertip is used to increase the warm red skin color of the woman's face. The texture of a fingerprint is a useful way of adding color in a specific, but subtle way.

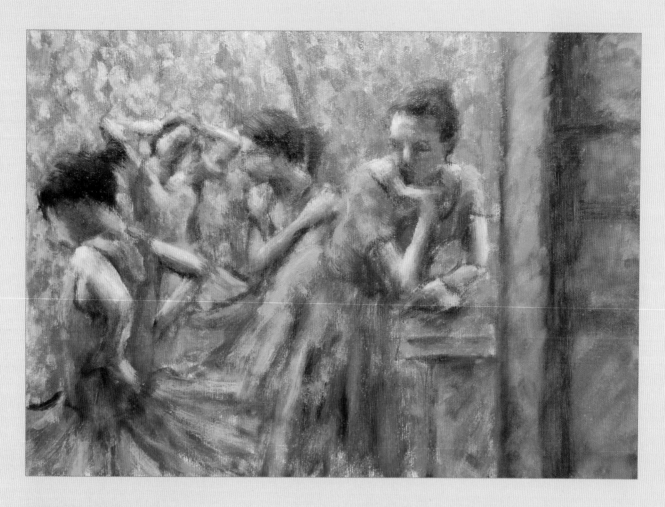

WORKING WITH LAYERS

One of the key things that Degas admired in the Italian Old Masters was the manner in which they built up layers of oil paint—in Titian's case in particular—adding depth, movement and atmosphere to the final work. This had led Degas to experiment with pastel layers and, in turn, when working in oil paint the pastel technique had its influences on the painter. Degas' later oil paintings are built up with loose, broken painted surfaces that are highly textured and leave plenty of gaps for the colors below to show through. He also applied each layer in ways that added to this translucency—scumbling and stippling the paint, as well as dabbing it on with his fingertips.

The intention here was to emulate Degas' later painting style with its build up of highly textured layers and complex color effects. This must be done in stages, with the paint being left to dry at each stage and color and contrast being increased along the way. The application of paint in broken marks or in transparent and translucent ways ensures that the effects of the layering approach are exploited to the fullest.

1

An arrangement of four figures, based on dancers posing and resting backstage, is sketched out in a dark neutral. Several attempts are made to find a satisfactory design with the larger figures in front overlapping with the smaller figures in the background. Where areas have been rubbed out or smudged, the buildup of tonal shapes helps add weight to the evolving image. Extra depth is added to the composition by a vertical line on the right-hand side suggesting a screen, or some scenery in the very foreground.

2

Color is introduced to the background and the screen in the foreground. A rough, scribbled mark is used so that the surface gains an animated quality, and so that some texture will be built from the varied amounts of paint. This is left to dry.

3

The dancers' costumes are blocked in, first with a dark, warm blue and then with a lighter, greener blue. The fourth figure is made to stand out more distinctly by painting her in an orange costume. More color is added to the background areas.

4

A detail shows how the hair is filled in with a lighter and darker brown. The same color has been used for each head.

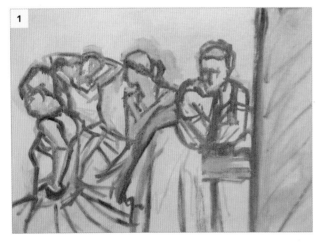

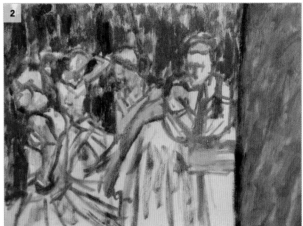

5

A thin sable brush is being used to place some delicate and carefully selected lines at certain points across the image. In places a semi-transparent blue line is painted over the blue dresses with the resulting effect that the line is made bluer by the multiplication of what is effectively a glaze. Any thin layers will have this glazing effect, where they modify the layer beneath, but in a way that depends on what is underneath— that is, depending on its color, tone and texture. This sort of line rarely flattens a form; its varied quality will create a more three-dimensional effect.

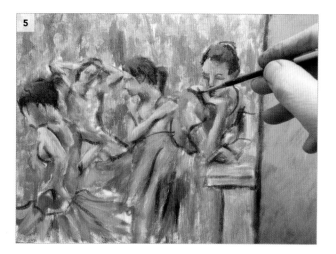

6

Now that the previous layer of transparent lines has dried it is possible to see their subtle effect, for example, on the dancers' arms, just loosely defining edges without standing out too much or flattening the forms they outline. Onto this dry surface lighter and brighter color is painted with a dry brush onto the costumes. The light blue is made brighter, or more colorful, by adding viridian green together with some white to the original coeruleum blue mixture. A similar heightening of color is made to the orange dress. It is worth noting that here, as with subsequent layers, less paint is applied each time and only to specific areas. Often these will be the lighter and more colorful places that one is trying to bring out and emphasize. The dry-brush mark allows the colors beneath to show through, and the contrast between duller and more heightened color will add depth. The warm skin tones on faces and hands are also brightened at this stage.

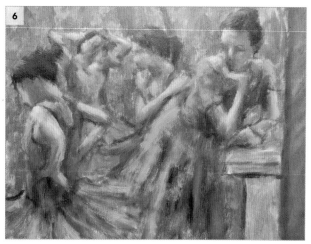

7

As the color is developed in the figures, the background colors are also enhanced. Fingerprint marks and stippling with the tip of the hog hair brush allow a mosaic of colors to be built up—it only takes a handful of marks to bring the color out sufficiently, without competing with the main subject of the dancers. More work is also done to elaborate on the foreground screen, helping it to emerge a little more.

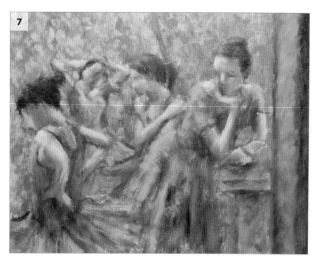

8

In order to strengthen the figures further, a warm brown is spread thinly across the dry surface of faces and hands. This tonal contrast adds a dramatic quality to the figures and also harmonizes the skin colors.

9

Specific additions of paint are made as final touches to the composition. A touch of light is added to the hair of the two foreground figures to help them stand out the most. There are always more possibilities of developing a painting further, and knowing when to stop is often the hardest part of the process. The best approach is to take longer between layers, and if it's possible, leave the painting somewhere where it can be looked at occasionally while you're busying yourself with a different piece of work. In this way one can look and weigh up the next steps without being drawn back into the painting. Very often a painting will finish itself by you eventually coming to the conclusion that just one or two very specific additions are needed to resolve the work. Putting an almost finished piece into a clean mount, or even a frame temporarily, is also an effective way of revealing whether or not it really is resolved.

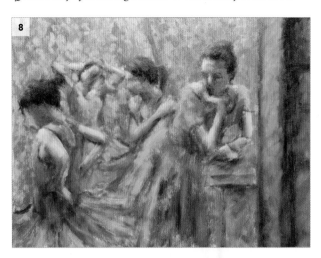

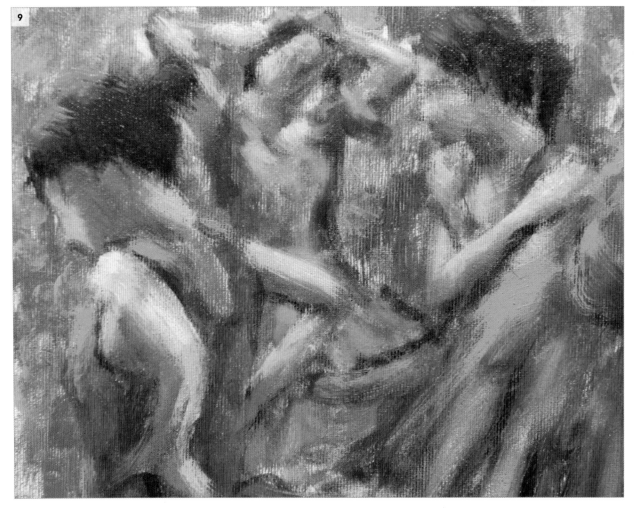

DEGAS & OIL
Masterclass: Combing the Hair

WORKING WITH LINE & CONTOUR

In his earlier paintings Degas was the *ingriste*, drawing many fine lines and restating them throughout the course of the painting. As his style evolved, he increasingly strove to lose the edges of his subjects and to restate these lines and contours in an ever more selective way.

In this example the lines and contours become less obvious as the painting develops. The canvas was prepared with a layer of brown ground—this is most easily done using acrylics (burnt sienna, and a little ultramarine and white) and a big brush. Preparing your canvas this way means that color can be seen immediately, so one is not fighting the white of the canvas, and also so that the composition is held together by this warm background even in the early stages. Since this is a mid-tone, the painting can then be developed with lighter and darker contrasts and—like the pastel paper—much of the surface could remain relatively unchanged (with only a few lines across, washes, scumbles and so on) if desired.

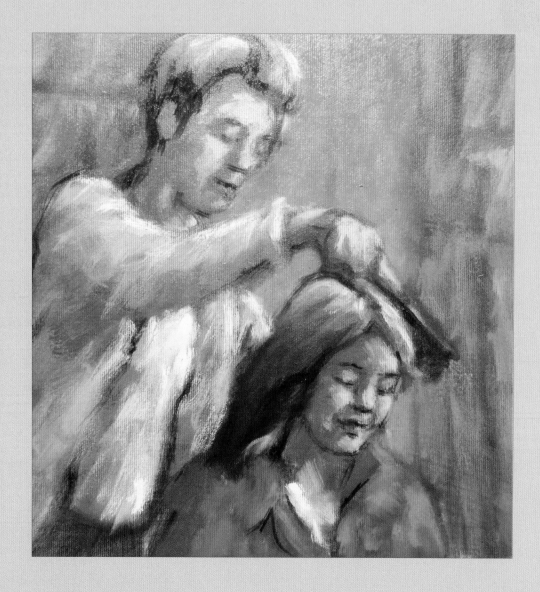

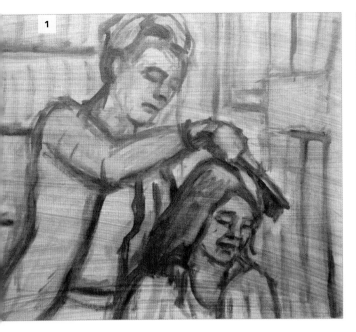

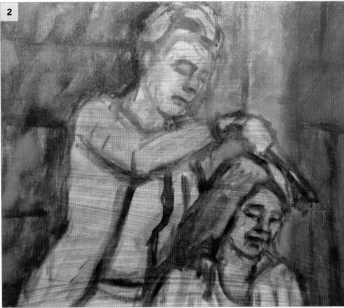

1

The composition is sketched out in diluted paint—a cool black made from alizarin crimson and viridian green. This painting starts with a line that may disappear under layers of color, but will also be restated along the way—following Degas' example, even as part of a final layer. You should feel free to use many lines and be uncertain about exactly where to place them— when Degas' critics said some of his numerous outlines seemed to suggest he had no idea where an arm, or a nose precisely was in a drawing of his dancers or bathing women, Degas agreed with them: uncertainty was a deliberate and desirable effect as far as he was concerned.

This diluted paint (thinned with turps and linseed oil) was called "ink" by the Old Masters and can be smudged and softened much in the way that charcoal can. This allows for a gradual adjustment of the line, a strengthening once it has been found, and a buildup of marks and tone that add weight and depth to the image. At this stage more detailed areas like features and fingers can be usefully summarized with an emphatic mark, for example, under the nose or under the forefinger. Later on more detail may be added to these particular places—or not.

2

When the initial drawing is dry, colors are blocked into the background areas in such a way that some of the lines of the interior space—the bookcase and window—are still visible through the spread-out paint, and done loosely, so that the contours of the figures are painted across in places. This means that outlines are already beginning to be lost; over the course of the painting their gradual reinstatement will be explored.

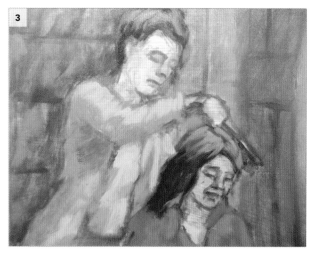

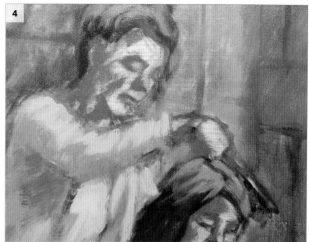

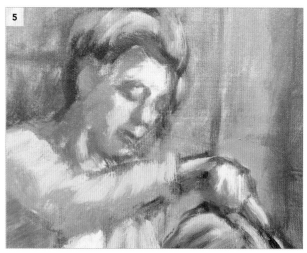

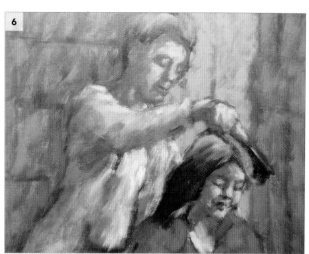

3

Hair and clothing are blocked in using a lighter and darker tone for each. More lines are being lost and the edges between the forms of the figures and their surroundings are becoming more subtle and varied.

4

Block in the faces and hands. It is worth starting with the shadow colors and working up to the lighter areas last. It is a common problem that we see the light and color, and neglect the subtleties of the dark and subdued passages. Proceeding in this direction enables you, the artist, to see everything at once.

5

Warm skin tones—a dull orange, then a lighter, pale orange—are hatched across the lighter areas of the faces and hands. More and more of the original lines are being absorbed into color and tonal shapes.

6

The background is lightened to help the two heads stand out from it.

7

Lighter colors are added to the clothing.

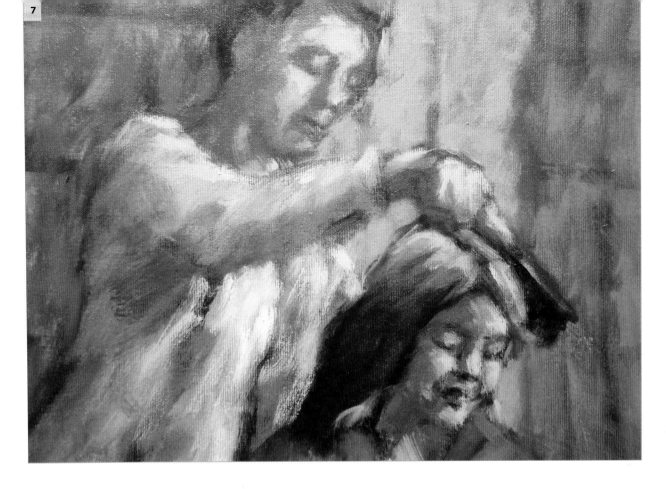

8

A detail of the girl's head shows the increased light and warmth in the painting. There are no complete lines left from the initial drawing out of the figures, but traces remain that help to define their forms.

9

Both warm (brown) and cool (black) lines are restated over parts of the image—notably the features of the faces (warm) and points around the clothing (cool). The transparency of the colors helps them to integrate a little with the surrounding paint, while adding a degree of emphasis.

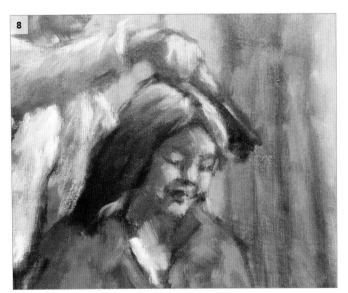

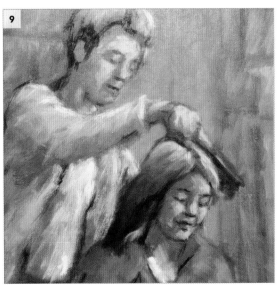

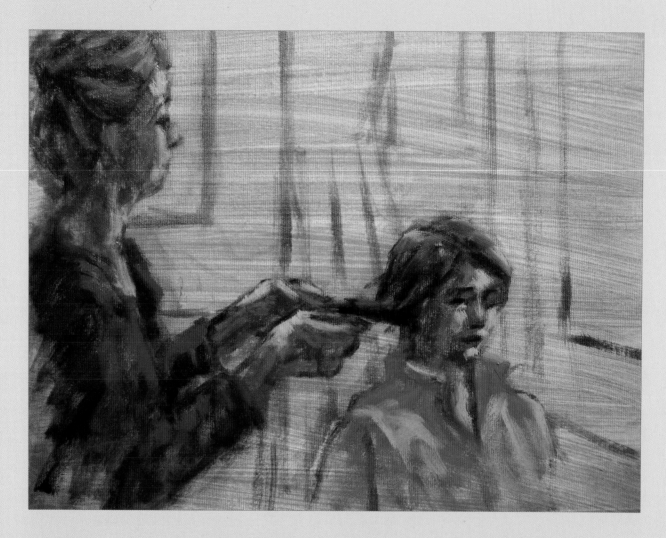

Degas evolved into a colorist, and it was his experiments with layering pastel that appears to have influenced the ways in which he built up color in paint. His earlier oil technique was much more about good draftsmanship being gradually colored and strengthened in paint. With pastels he had a rapid and graphic means of building up opaque layers of color that, unless it was smudged, would always result in gaps between marks through which lower layers could be seen. The speed of the process as well as the finite range of pastel colors allowed Degas to try out an enormous number of permutations of layered color schemes. This may well have informed his choice of colors in the vibrant, layered oil paintings of his later work. He certainly would have understood the management of the contrasts between layers and the type of translucent or broken mark needed to allow one layer to be seen through another.

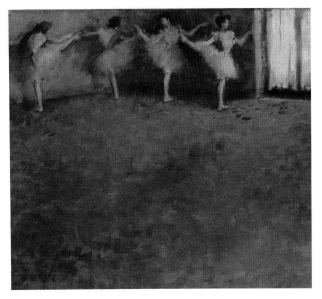

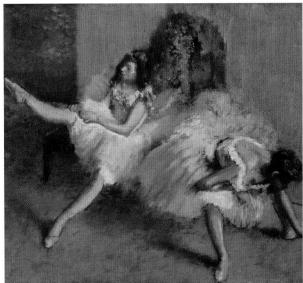

Working with a limited palette implies using fewer colors but choosing them carefully for their relationships to each other, or according to how they affect each other. Opposite colors on a color wheel are complementary and produce striking visual effects when placed side by side. So when Degas uses few colors, if he selects colors that excite each other, the painting will be more vibrant even with a limited range of colors. If there is a quiet or muted area in the painting, such as the floor in the two details (above) from *Before the Ballet* (1888), Degas keeps it lively and interesting enough by putting opposite muted colors together; here, for example, he places dull pink next to dull green. Similarly, the wall behind the main two figures contains almost opposite orange and green-blues side by side.

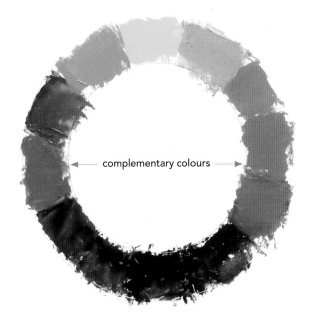

complementary colours

DEGAS & OIL
Masterclass: The Wrong Colors

1

A composition based on the figures of a woman and a girl having her hair arranged is sketched out in black diluted oil paint on a brown ground on canvas. A fluid line outlines the contours of the figures and some suggestions of a window and curtain behind them.

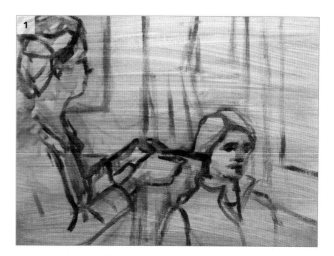

2

The faces, hands and hair of the two figures are loosely blocked in with what you might call "the wrong color." The normally warm, dull green shadows on the skin are treated instead with a cool, bright green. The hair, normally a yellow-brown is filled in with a blue-black. Similarly, the clothing—a purple cardigan and a pink jacket—are blocked in with a mid-tone blue and a pale violet, respectively. This layer is now left to dry.

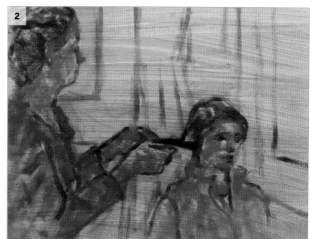

3

More naturalistic warm skin tones are prepared on the palette and heightened a little. For example, the warm, mid-tone dull orange is brightened (by increasing the orange in the mixture) and laid across the dry areas of the face and hands. As with other examples of painting in layers, here gaps are left in between brushstrokes as the areas are loosely filled, therefore a number of things happen with the colors involved. Where the colors of the two layers sit side by side and are clear, they complement each other and liven each other up. When the orange color of the top layer is spread out thinly across the green underneath, however, the colors appear to mix and create more muted versions of each other. Finally, the clear difference between the colors of the two layers creates depth in the image—a physical depth, because one layer is on top of another—and a depth of color as one contrasts with the other. A similar approach is also taken with the yellow-browns applied to the hair.

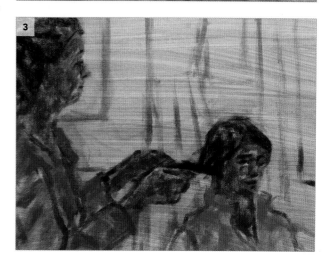

4

A second, lighter, naturalistic skin color is dragged across the parts of the heads and hands that are catching the light. The detail shows how different colors are affecting each other—the greens and oranges complementing each other, and the warm light against the shadow combination are also contrasting with each other.

5

The right colors are applied to the mid- and light tones of the clothing. This process will continue with the background areas. It will also be possible to extend the range of right and wrong colors in the figures. The key thing to take account of will be just how much contrast and busyness these effects will generate, and it will be necessary to manage the vibrancy and noise of the color combinations. It would make sense to have some quieter passages as a balance to the intense effects illustrated here. Perhaps the first layer of background colors could be less contrasted with what is to follow, potentially more naturalistic, so that the resulting layers will be quieter.

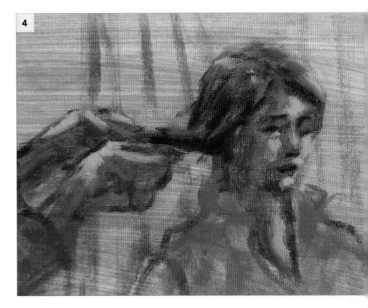

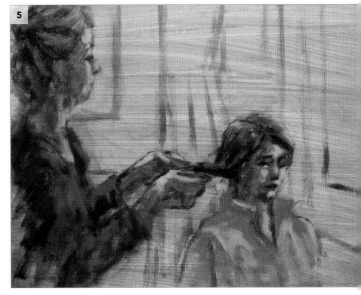

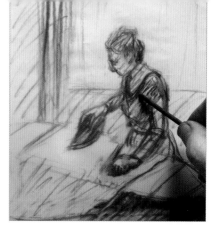

DEGAS & OIL
Exercises

The following four exercises offer a way of exploring some of the approaches that Degas took to working with oil paint, and in particular the questions of line, or contour, color and the building of layers. The traditional approach to oil painting often began with the two stages of sketch and study. Here, sketches were made of a woman ironing and then a different process was followed in each case to develop the image from the idea through to a resolved oil study.

1 WORKING TO LOSE THE LINE

Draw a composition in charcoal on tracing paper (top) and adjust the format if necessary, perhaps to a squarish design if that seems better.

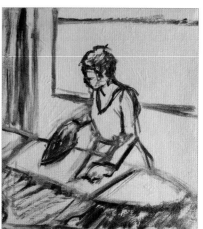

Sketch out this composition in black diluted oil paint onto a small canvas tinted with a beige ground (right) and leave to dry.

Block in the colors of the clothing, the skin tones and the main objects in the study—for example here (below right), the color of the iron and the board. For these colors mix light and dark versions, increasing the strength of the color in the lighter mixture. Hatch the colors across the areas letting the original outlines disappear as you do.

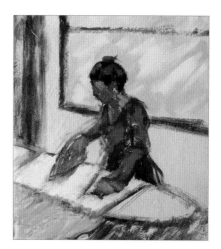

Continue the process of losing the lines by filling in the other background areas and creating new edges, or borders, where each color meets (bottom). Adjust the main colors where necessary to create a more harmonious effect.

2 NO LINES

Begin with a charcoal sketch on tracing paper (top right). The figure of the woman ironing was initially placed on a rectangle, but after some consideration it was decided that a squarer format made a better composition—indicated by the black vertical lines showing the limits of the new design.

Using your sketch as a reference, begin to paint in the main color shapes, without the use of line. Instead, hatch in the shapes in an approximate way—this is similar to the drawing exercises using tone or value in Chapter 3. As you fill in each shape it becomes easier to judge its accuracy, and edges begin to develop, which create outlines, or limits to the form of the figure and other elements. The beauty of this approach is that it allows you to concentrate more fully on color and make adjustments accordingly. In this study, for example, the light in the window is warmed with extra orange, and other colors subdued or brightened.

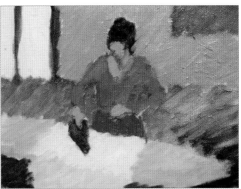

Now scrape the painting down with a palette knife to obtain a smudged and softened effect (center right).

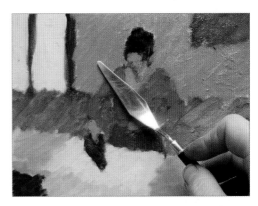

Continue to develop the color and contrasts with lighter and darker variations of the main colors—but avoid defining anything with lines (below right). Use the negative shapes around the figure to refine its contours.

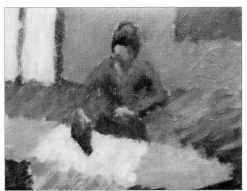

When the painting is fully dry, use a thinned black mixture of alizarin and viridian—which will have some transparency—to paint selective lines that define some of the features and edges of the figure (bottom right). Experiment with reducing the effect of the lines by dabbing them with a clean rag to smudge and soften them. Aim to use as few lines as possible.

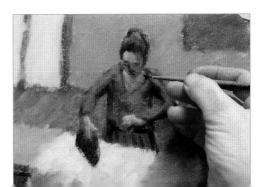

3 BUILDING LAYERS

Make another sketch of the same theme (top left). This time the aim is to develop a sensitivity to what is happening in the painting and on the surface of the painting.

Take an old, unwanted painting as the starting point for this exercise and turn it upside down, then sketch out your composition with fluid black oil (top right). Initially the original image will persist and can be hard to ignore, even upside down.

Eventually however, as the new image is completed in line, it becomes more dominant and even at this early stage you should be able recognize the potential happy accidents, where the texture, color or value of the old painting coincides usefully with the new (bottom left). Rather than obliterating it in the

next stage of blocking in, try to incorporate what you can see of the old painting, modifying if necessary, but not losing it altogether. What is hopefully being cultivated through this exercise is a sensitivity to a particular direction that the painting might take you.

The woman's top is blocked with lighter and darker shades of pink, and the figure is becoming stronger (bottom right). Fortuitously, the pink from the old image is slightly different from that in the new mix, and there are also light blues and grays in there—therefore the colors in the top immediately appear more complex and interesting. The pattern of almost vertical stripes that falls through the outline of the ironing board also looks quite promising and may be adopted and adapted for the final stage.

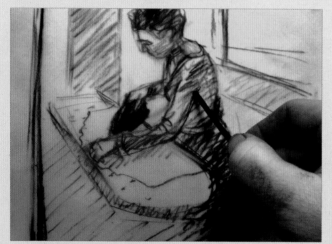

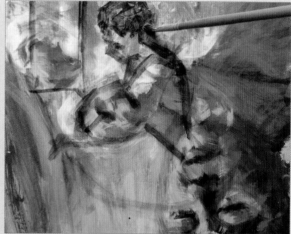

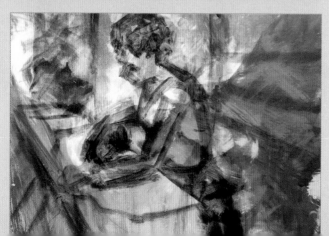

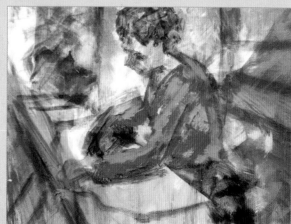

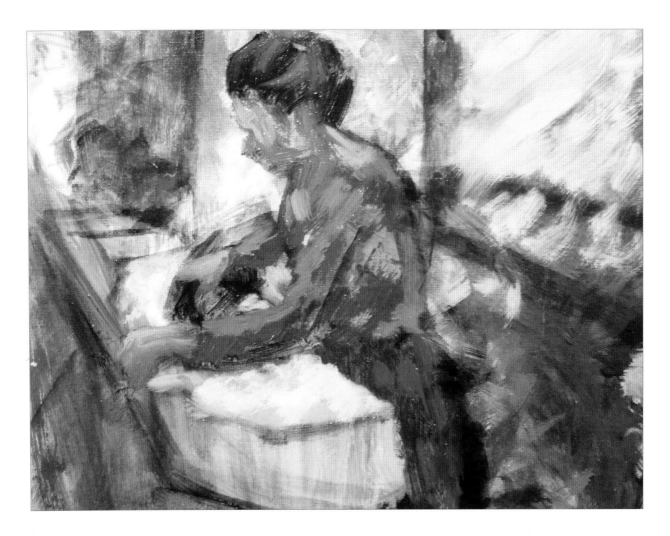

Once you are happy with the sketch, apply a first layer of new color to the figure—clothes, hair, head and hands. I have also blocked in the window with some lighter paint. The image should now be beginning to come together. It may still be possible to make out some details of the original image—in the example above, for instance, the upside-down head—but generally the combination of old and new paintings will give the new layers a tremendous depth and an intruding quality. A consequence of this process—of not wanting to overlook, or miss what has been given by the old canvas—is that new marks are made in a fresher and more economic way. One is inclined to do less rather than more, and with great sensitivity. I would suggest that this is the very state of mind of an artist

such as Degas, who was always highly attuned to what was happening in his paintings, was always ready to seize upon any gifts that came his way. Indeed, Degas adopted various working methods in order to make such accidents and discoveries part of the process—the reversal of the image in the production of a monotype, the scraping down of oils while painting on canvas and so on.

Allied to this is the fact that the original layer is so different from the new—with different colors and shapes; a different intent—that the new layer will stand out strongly from what is underneath, whatever the coincidences, and this will create a tremendous amount of depth in the resulting image.

4 THE WRONG COLORS

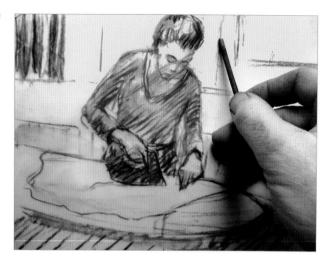

The previous exercise demonstrated an approach to layering color in such a way that the difference from one layer to the next generated a complexity and depth—but all done with a large degree of chance. The fourth exercise suggests a way of taking advantage of the subtlety and surprise of the last exercise, while retaining some control over this layering of color.

Make a sketch in charcoal to decide the composition (top).

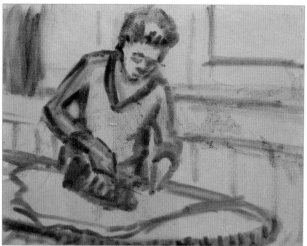

Sketch this out onto a small canvas in diluted black on a beige ground (middle).

This time colors should be blocked into the main foreground features—for example here (bottom right), the clothing, head, hands and ironing board, and so on—but in the wrong colors. It might be the wrong green for shadows in the skin (too cool and too colorful), or the wrong gray for the ironing board and shirt (too dark); sometimes it might be very different from what would be the right color, and at other times only slightly.

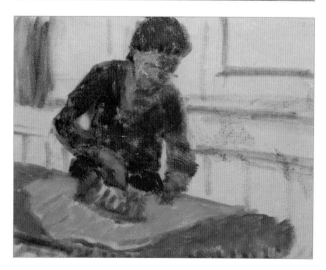

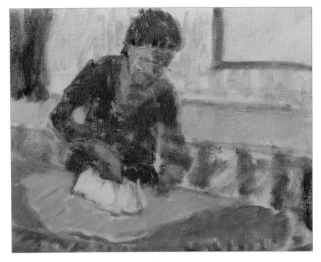

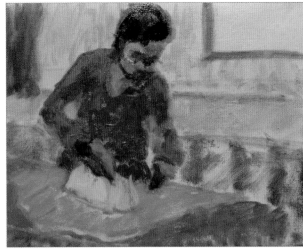

Fill in the rest of the painting with more wrong colors (top left). The image is looking rather like German Expressionist painting of the twentieth century, but it illustrates the instinctive ways in which Degas would build up color in both pastel and oil paintings. He might start not with the true color, but rather its complementary opposite; or a duller version of the true color; or an intuitive choice of something that might relate well or combine well with the true color. Deal with the background in a similar way.

Apply a brown thinly to the hair and face to indicate some of the darker landmarks of features (top right).

The next stages will be a gradual process of applying the right colors to the dry painting, leaving gaps in your brushwork so that the two color schemes can continue to work on each other (bottom left and right). The final effect will depend on how well these two layers work together—a little red showing through brown hair will probably just warm it up a little, however, the sharp greens coming through under the warmer skin tones as they are added will create a strong contrast and surprising color effects.

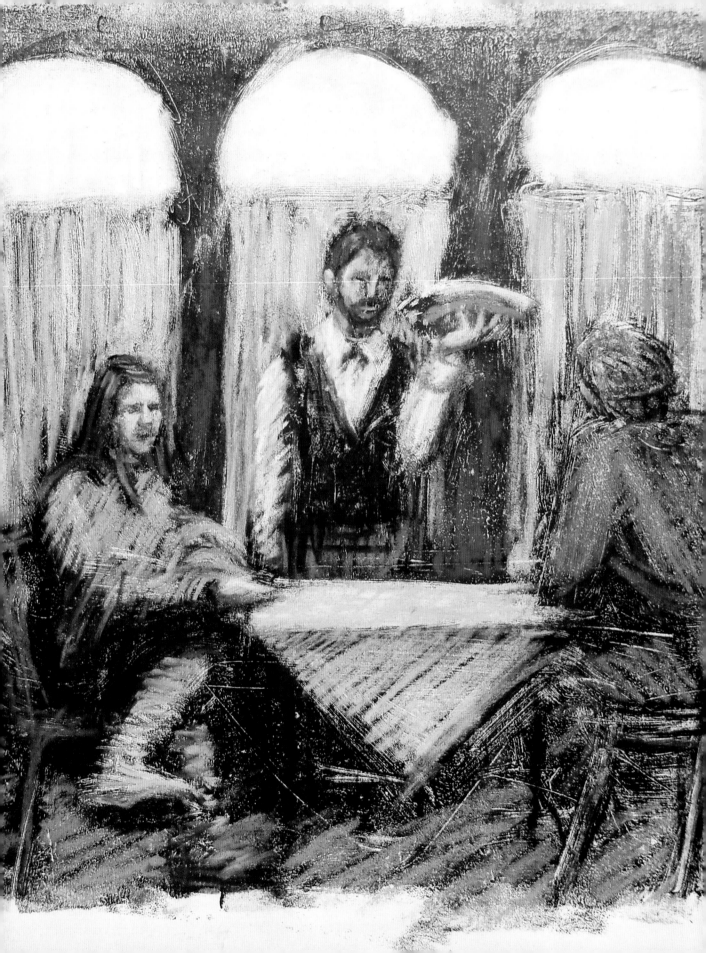

CHAPTER 5: DEGAS & MIXED MEDIA

Degas was often described as having a restless artistic nature—always experimenting with different versions of the same image, adapting his materials to create new effects, and combining materials in innovative ways. Since Degas' time, working in mixed media has become a common practice, but the combination of a print laid over with chalk was unusual, particularly to be exhibited as serious artwork. However, several features of this technique are also key to Degas' use of other materials— a desire to work in layers, building up material in such a way that edges could be refined, lost and found. It also allows for color to be developed in an instinctive way, and so that there is plenty of scope for the happy accident. The technique of pastel over monotype is a prime example of all this. The production of a monotype is a rapid and exciting process that requires drawing in an instinctive and innovative way. The print that results from this process is a reversal of the original image and therefore presents a new version of the original idea. The rough, atmospheric image of the monotype then needs to be subtly refined by layers of color—always keeping some of the original quality and mood. The layers of pastel add depth to the image as well as the range of colors from subtle to vibrant.

In this chapter the separate stages of producing a monotype and then developing it with layers of pastel will be demonstrated. The parallels with other techniques such as the charcoal under-drawing as a beginning for a pastel painting should be clear.

DEGAS & MIXED MEDIA
Making the Monotype

A monotype or monoprint is an image produced through a printmaking process that generates only a single image. Once an imprint has been taken, the plate has lost most of its inky surface and the process needs to be restarted. This technique can be done in an elaborate way in an equipped printmakers' studio using oil-based inks, pre-soaked papers, and printing presses. But it can also be done in a far more low-tech way with water-based ink, basic papers and a hand roller to make the impression. Many artists experiment with monoprinting: the speed of the process and the dramatic quality of the images can often act as an inspiration and a way of developing ideas through a process of discovery.

Begin by spreading the ink over a palette with a palette knife and then use a roller to spread it evenly across palette (top right). This will be used for coating and re-coating the roller with an even layer of ink.

Then roll this ink onto a Perspex sheet (center right). Roll the ink out in both directions so that a reasonable coat is achieved. Holding the Perspex up to the light can help you judge how well spread out the ink is. It is likely to be textured with dots and pits allowing the light to shine through—this is fine. It is a foretaste of the instant atmosphere that comes from printing using this method.

Using rags, sponge, card, fingers and whatever else you can think of, wipe the ink off the plate in order to create the right tonal and textural areas or shapes for the subject. Areas where the ink is almost completely wiped off will come out white in the print, while other areas that retain some ink—lifting some of the ink off but leaving some behind with a texture of vertical swipes—will print as a gray lined pattern.

Using a rag stretched over a forefinger, wipe away areas of the black ink that need to be gray or lighter for the image to emerge (bottom right). For this first print of a man at a café table the figure is brought out by wiping away the negative shape around the body and hat. Once some of the ink has been wiped off, the background area is wiped again in a consistent vertical direction, creating stripes behind the emerging figure, suggesting a wall or a curtained window.

If the Perspex sheet is held up to the light an impression can be gained of the likely effect on printing (top right). Ideally all areas of the plate will be worked on, if only to disrupt the original layer of ink—just wiping it in an appropriate direction can be enough (vertical for walls, horizontal for floors, and so on). Notice how in this image the light gray triangle of the table cloth is also helpful in defining parts of the figure and in pushing him back slightly into the interior space.

Degas was typically inventive with the way in which he made a whole variety of marks and textures: fine scratches with the end of a brush to sharpen a light edge; or reprinting with an inky fingerprint the face or a belly of a figure. A good gauge of whether or not a plate is ready for printing is to ensure a full tonal range—black through grays to white—and to maximize the number and variety of types of marks.

Make a print by laying a sheet of newsprint onto the wet ink (center right). It is wise to initially check a corner of the print to see that enough ink has been transfered onto the paper, testing that the dark areas have come out dark enough, before you lift the paper fully off. Like this, the print can be re-rolled more firmly if necessary. Newsprint is being used here as it is particularly sensitive for this process. Because it is so thin, it picks up every mark without the need to squash the ink and all the textures in the process.

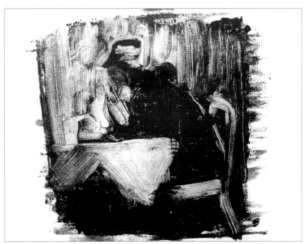

The monotype is of course a reversal of the original image wiped out of the inky plate. This transformation was the sort of surprise that seemed to delight Degas. You will recall that he often composed on tracing paper just so that he could reverse the image and hopefully discover an even better arrangement than that which he had first thought of.

The image at bottom right shows a second proof. This one is much fainter and contains far less variety (hence the name "mono-type"—only one decent print can be made by this method, as opposed to the multiples that can be generated by etching, screen printing and so on), but it can still be used. Degas often worked up the weaker print and held onto the first as an image in its own right—it can be used as a guide to developing the pastel color stage.

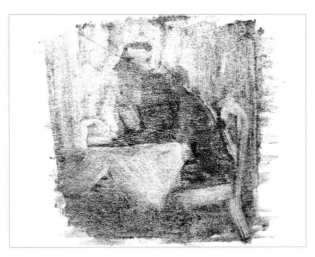

DEGAS & MIXED MEDIA
Pastel Layering

The next stage in the process involves bringing in other media. The first proof (below) is modified a little with a few charcoal marks, then some pastel colors are applied to the figure and the background. In some places the figure needs to be strengthened, like the arm on the table; and in others the negative shapes around the figure are worked on in pastel. The shape under the man's chin is important for defining his head, arm and shoulders, and for capturing his particular pose—that of looking away, as if in thought.

As has already been seen, applying pastels to a dark under-layer makes their opaque colors stand out strongly and adds depth to the image. Many of the points made about pastel technique are relevant to this mixed-media approach. In order to exploit the atmospheric qualities of the monotype and to enhance the depth, the ways in which pastel is applied should make it possible to see through these layers. Here, Degas' variety of marks comes into action again, both in order to describe the various textures and patterns of his subjects—the clothing of the figures, the architecture, the furnishings and so on—and also so that the most is made of the layered approach. As with the pastel-painting method, the amount of pastel applied will vary in different parts of the image. Some areas of the background will have almost no pastel—perhaps just a thin wash applied with the side of the stick—so that the textured inky marks are still visible. Other places will be highly worked with intense layers of color that strengthen and emphasize them.

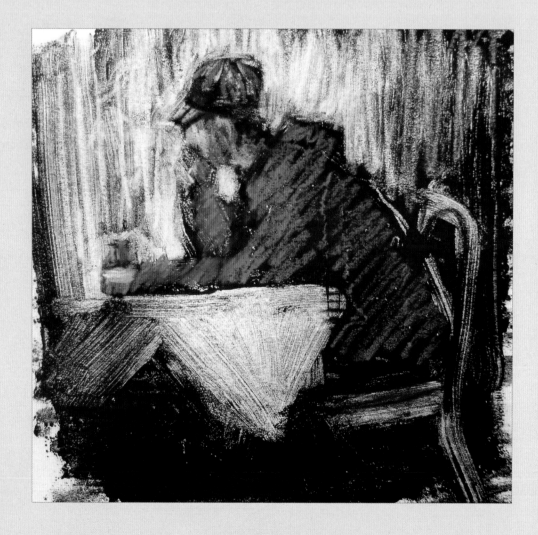

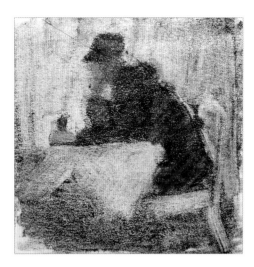

The weaker second proof is also layered with pastel colors (right). The overall effect of this image has less contrast, notably with fewer dark tones. When the pastel is applied, the color makes far more impact, and a second layer (below) results in quite a different outcome for the second proof. It is overall a much lighter and more colorful image than the first.

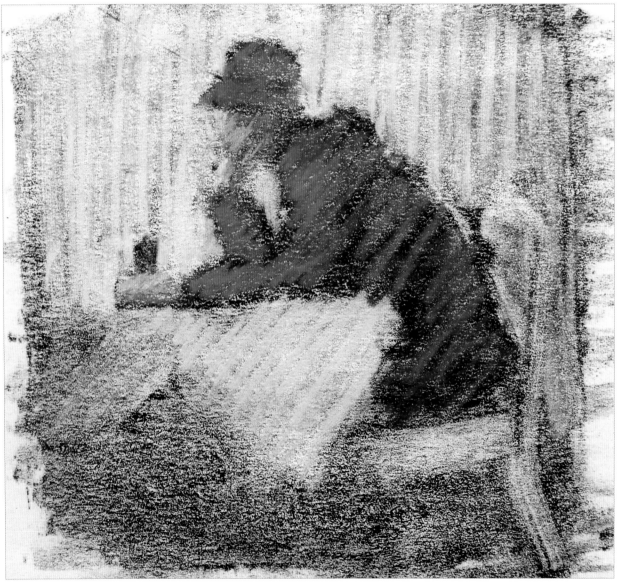

DEGAS & MIXED MEDIA
Printing on Cartridge

The process begins again, with a new image printed onto cartridge paper, which is thicker and therefore less sensitive than newsprint; so some of the delicate marks will have been squashed (top left). However, this paper is also more robust and it will be able to withstand many layers of pastel and fixative. Since the result feels like a less complete image than the newsprint example, there is more incentive to do

something with it. A perfect monotype is hard to spoil. A little work is done to the image in charcoal, adding a few defining marks and dark shapes to the figure, helping the woman emerge from her surroundings (top right). This is then worked up with layers of pastel, but not so much that the original print disappears entirely (bottom left and right).

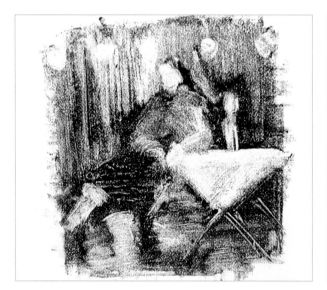 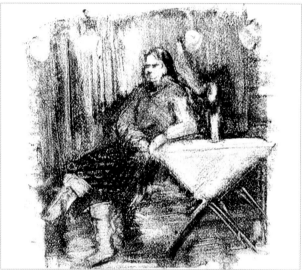

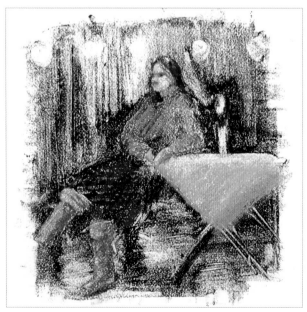 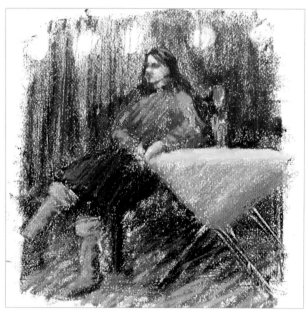

Here, a print shows a range of marks made mainly with a finger with cloth stretched over it, or sometimes with a finger nail or a finger tip. A tonal range has been laid out along the bottom, from white (ink wiped completely off the Perspex) through various grays, to black (the original untouched application of ink to the Perspex sheet). These marks show how monoprinting is an opportunity to draw light falling on different surfaces, or shining out of dark surroundings. Hence Degas liked to use this method as a good base in some of his themes—the café lit by electric light at night-time, or a woman drying herself after a bath, her figure silhouetted against the window.

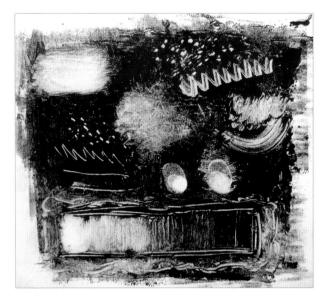

Water-based inks will be most convenient and can be printed by hand with a clean roller. Oil-based inks are of better quality and offer more sensitivity, but need a press and a well-equipped print studio for best results.

THE MONOTYPE LEXICON

The different implements listed in Chapter 1 will generate a great variety of marks as the ink is removed from the plate, or spread out, or moved from part of the plate to another. The following images show both the implement in action and the resulting print. As ever, the most useful approach is to try lots of experiments and keep track of the outcomes so that you can apply the different approaches to your images.

Working with sponge.

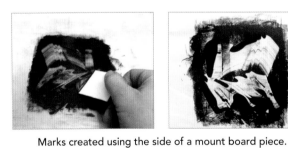

Marks created using the side of a mount board piece.

Rag stretched over finger.

Marks made using a scrunched up piece of paper.

Brush end/sticks.

DEGAS & MIXED MEDIA
Masterclass: Café Scene

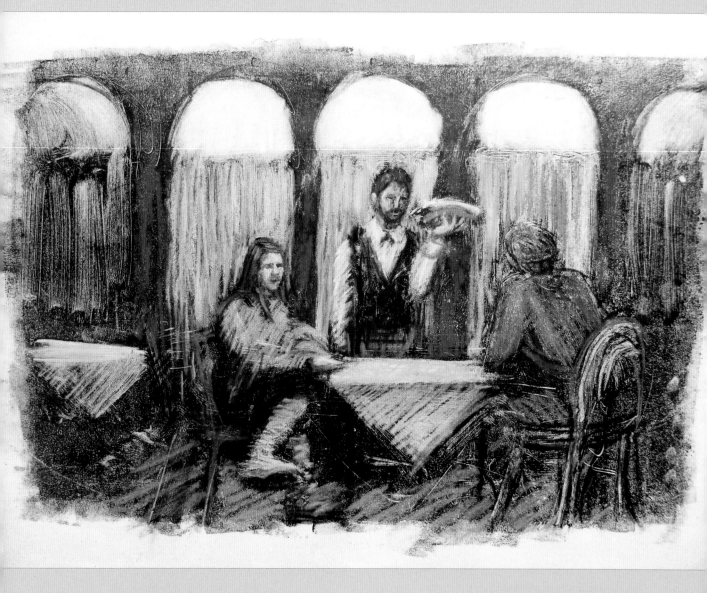

This demonstration illustrates some of the considerations Degas might have made in constructing a mixed-media image based on three figures in a café. Drawings were made from two models who dressed for the roles and took it in turn to play the parts of both customer and waiting staff. The resulting image was contrived by combining several poses from the drawing session and a café interior taken from a local shop.

1

The materials required for making the monotype: block-printing ink, a printmaker's roller, a Perspex sheet, and various implements such as rags, sponges and pieces of card for working into and lifting off the ink. The Perspex sheet, or plate, is uniformly covered with the ink by first loading the roller from a supply of ink prepared on another surface such as a palette. Using the rags stretched across a finger, or the sponge, some of the ink is wiped from the plate in order to create the various tonal differences. Most of the ink is wiped off for the areas of the windows, for example, and for the table tops of the café, so that these will print as white—or the clean white of the paper.

2

Holding the plate up to the light, the areas where ink was wiped almost completely off can be seen as the lightest in the image. The darkest areas are those untouched, or barely touched with the rags or other tools. The real challenge at this stage is to create a whole variety of tones and textures appropriate to the specific elements in the scene. Here, the net curtains below the arched windows are gently wiped so that the ink becomes slightly thinner and so that a vertical texture, like the grain of a brushstroke, is left—this will print as a gray and help suggest the translucency of the net curtains. The three figures in the scene require some thought as to the kinds of marks and textures to make in order to suggest the tone and pattern of their clothing, for example, the waiter's black-and-white uniform with the attendant gray shadows. Ideally every part of the plate will be worked on, if only to disrupt the original layer of ink. Just wiping the ink in a particular direction without lifting any off can be effective—vertical marks work well for walls, and horizontal strokes for floors. As well as subtracting the ink, Degas would sometimes add a mark or two—notably a fingerprint for a face; curiously, the texture of a fingerprint conjures the effect of a face perfectly.

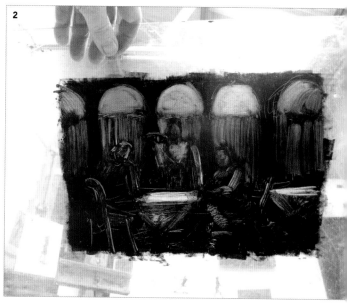

3

A sheet of newsprint is laid over the plate, and using a clean roller, an impression is taken. It is best to roll in different directions in order to get a reasonable consistency and so as to not miss any part of the image—however, the distinctive quality of the very textured monotype means that one isn't after anything too perfect here.

4

It is always good practice to check that enough ink has been transferred from the plate to the paper—you will see this if the black areas really are black. By lifting a corner of the print this can be assessed and if necessary the print can be re-rolled more firmly without the place being lost.

5

The monotype with its clear architecture and furniture—if you compare the print with the image on the plate in step 2 on the previous page, the reversal is clear. At this stage the figures are still little more than an impression, but they can be developed with a minimum of marks. Some charcoal marks are added to the print to refine some of the shapes and edges created by the wiping of the ink with the rag. The challenge at this stage is avoiding the temptation to over-define things, for example by outlining the figures to make them stand out. The beauty of the technique is that the subject is emerging in a very atmospheric way from the fog of black ink, and often it is shapes rather than lines that create the effect of a figure or an interior. One needs to refine sensitively, with a similar broken, textured and varied mark—almost to disguise the charcoal additions, so that they have the appearance of printed ink.

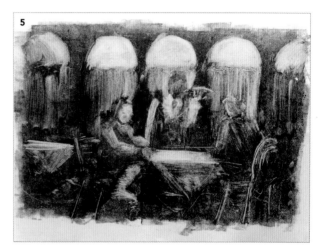

6

Pastels are then applied to parts of the monotype. Hatched and scribbled marks are better than solid layers of color, as these will allow the textures underneath to show through and help convey the form, tone and surfaces of the particular part of the scene. The process of creating the image through layers of color and tone gives it greater depth and weight.

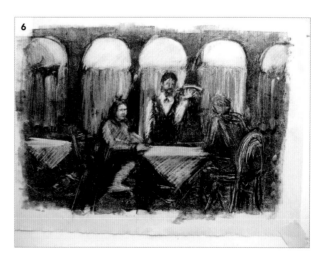

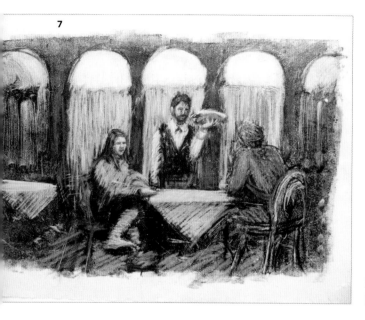

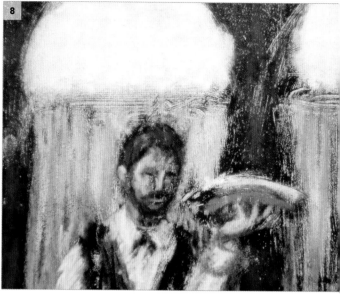

7

As with any image in any media, it is important to keep things unified and to deal with the larger areas in a way that balances with the details. Here, a thin layer of brown pastel is applied using the side of the stick to the walls and floor. This warms up the black ink of the monotype and therefore warms the image as a whole, transforming tone into color. You can see how this color is also repeated in details of the skin tones and hair of the figures. Other refinements are also now made to the figures and the furniture.

8

In this detail you see how the figure of the waiter is developed by refining the negative shape of the curtain behind him. As with the pastel paintings in Chapter 3, the colors laid over the monotype can be sealed with fixative and another layer applied. In contrast to the pastel paintings, I think one always needs to be sure that parts of the original monotype remain exposed in places—continuing to unify the image and adding depth to the overall effect.

9

Another detail shows that the pastel is applied loosely, so that between the hatchings the inky marks are just visible.

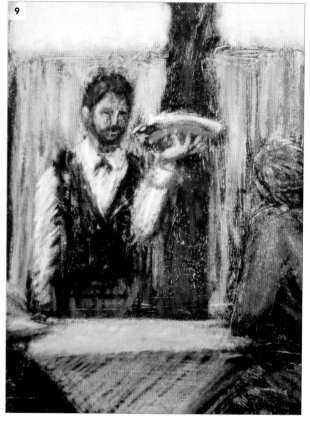

DEGAS & MIXED MEDIA
Exercises

1 MAKING THE MONOTYPE

Take some photographs of someone standing against a window in a room with some daylight coming in. Try to include parts of the room that are less well lit, pieces of furniture, and patterned and textured materials such as carpet and curtains.

Print the photographs in black and white and then see how many ways you can find of representing the different lines, tones, patterns and textures of the subject.

Use rags of different thickness, sponges and card, and aim to be as varied in your mark-making as you can. Try very loose impressions of your subject—leave plenty of scope for pastels and charcoal layers to define and resolve the image. Print on newsprint and work quickly producing plenty of tests.

2 PASTEL LAYERING

When the monotype is dry make several black-and-white photocopies of it. The challenge in coloring the monotype is to find a set of limited colors to bring out the image and yet leave plenty of possibilities for appreciating the inky marks below the surface. Often, the search for a good color scheme results in too many colors being tried and a buildup of pastel that obscures the monotype. With each of the photocopies experiment with a limited set of colors to see what you like.

When you have identified some color schemes you can use them on the monotypes in a much more economical and fresher way.

GLOSSARY

acrylic
Pigment ground in acrylic polymer emulsion.

alla prima
Italian term literally meaning "at the first attempt." Oil-painting technique where canvas is completed in one session before the paint has dried, in contrast to the slower method of building the painting up one layer at a time. Also known as "wet-on-wet" and "direct painting."

atelier
Artist's workshop or studio.

block printing
Printing from hand-carved wood or lino.

calligraphy
Highly decorative handwriting.

cartridge paper
Thick white paper made for ink and pencil drawing.

charcoal
Carbon-based drawing sticks made from wood (usually willow) burnt without air, available in various different sizes and degrees of hardness.

complementary
One of a pair of colors situated opposite each other on a color wheel—for example, green is the complementary color of red.

composition
The design or arrangement of the different parts of a drawing or painting.

Conté crayon
Brand of crayon made from graphite and clay developed in 1895 and named after its inventor, the French artist and scientist Nicolas-Jacques Conté.

crop
To cut off or mask unwanted areas.

ébauche
Preliminary underpainting or quick sketch for an oil painting.

fixative
Layer of varnish or similar sealant sprayed onto pastel or charcoal to seal and prevent smudging.

float
To lay oil paint lightly on the (wet) surface of a painting.

gesso
Plaster mixed with glue to seal canvas or other surfaces onto which oil paint is to be applied, to prevent oil soaking through.

glaze
Thin, transparent layer of paint.

gouache
Water-based paint in which pigment is bound with gum.

ground
The surface onto which paint is applied, usually first coated with a primer, such as gesso.

Impressionism
Style of painting developed towards the end of the nineteenth century, characterized by short brush strokes, heightened colors, and an interest in the effects of daylight.

ingriste
Following the style of Ingres; a disciple of Ingres.

ink
Fluid or paste used for drawing or printing.

linseed oil
Paint binder commonly found in oil paints, also used as a paint medium to make oils more fluid and transparent.

master
A senior artist under whom an apprentice or student of art would train.

medium
1. The material or materials used to create a work of art, such as pastel or oil paint.
2. Substance added to paints to control and alter their consistency.

mixed media
An artwork created with the use of more than one type of media, such as pastel and monotype.

monoprint
See monotype.

monotype (or monoprint)
Printmaking technique in which only a single print is generated.

mounting board
Cardboard onto which prints are mounted for display. Off-cuts are useful mark-making implements when working with the monotype technique.

newsprint
Low-quality, thin paper used mainly for newspapers.

oil paint
Pigment ground in oil; usually linseed oil.

Old Masters
Collective term for certain European artists working before 1800, whose work was characterized by great technical skill and beauty.

palette
Smooth surface on which paints can be mixed in preparation for painting. Also refers to the set or range of colors used by a particular artist or in a particular work.

pastels
Pigments ground with chalk and bound with gum water into drawing sticks. Available in various degrees of hardness and strength of pigment.

peinture à l'essence
Modified oil paint from which oil content has been extracted and then diluted with volatile solvent such as petrol to speed up the drying of paint.

pigment
A coloring matter or substance, such as oil paint or pastel.

plate
The surface onto which ink is first applied and from which a printed impression is taken.

realism/realist
Style of painting developed in the mid-nineteenth century in which things are depicted as they really are, avoiding artificiality or stylization.

scumble
To soften the color of a painted area by overlaying with opaque color applied thinly with an almost dry brush.

size
Glue used to seal paper or canvas surfaces.

stipple
To paint with dots or small spots.

tone (or value)
Lightness or darkness of a color or mark, independent of its hue.

tooth
Rough surface of paper or pastel-coated paper that has been sprayed with fixative.

turpentine (turps)
A solvent distilled from resin, used for the thinning of oil-based paints.

value
See tone.

wet-on-wet
See alla prima.

INDEX

ACKNOWLEDGMENTS

I need to thank Hilaire-Germain-Edgar Degas for being the reason for writing this book and for having taught me so much. I also owe a debt to Bernard Dunstan R.A. for his analysis and clear explanations of Degas' methods. But I wouldn't have done it had it not been for Ruth, Isaac, Iris, Inez and Yvan.

Finally, thanks to the Ilex team—Zara for asking me, and Nick, Natalia and Rachel for guiding me through it all.

PICTURE CREDITS